SYNCHRONIZATION
FROM REEL TO REEL
JEFFREY RONA

A Complete Guide for The Synchronization of Audio, Film & Video

Edited by RONNY S. SCHIFF
Associate Editors SCOTT R. WILKINSON, JON EICHE
Graphic Design by ELYSE MORRIS WYMAN & LACHLAN WESTFALL
Drawings by RICHARD KING
Diagrams by LACHLAN WESTFALL
Computer Cover Graphic by COLIN CANTWELL
Cover Design by ELYSE MORRIS WYMAN

for
Fred
and
The
Starlets

Library of Congress Cataloging-in-Publication Data
Rona, Jeffrey C. (Jeffrey Carl), 1957-
Synchronization, from reel to reel

1. Sound — Recording and producing. 2. Magnetic
recorders and recording. 3. Video tape recorders and
recording. 4. Sound motion pictures. I. Schiff, Ronny S. II.
Wilkinson, Scott R., 1953- III. Title.
 TK7881.4.R66 1989 778.5'344 89-14026
 ISBN 0-88188-905-9

PITTSBURGH FILMMAKERS
477 MELWOOD AVENUE
PITTSBURGH, PA 15213

HAL•LEONARD™
CORPORATION
7777 W. BLUEMOUND RD. P.O. BOX 13819 MILWAUKEE, WI 53213

TABLE OF CONTENTS

FOREWORD

In my inauguration working in recording studios as well as in film and video production, something became very clear to me: while the people involved in a specific project each understood their own job and how to do it, they often did not understand how everything fit together as a whole. This seems especially true in film post-production and, perhaps to a lesser degree in recording work as well. In professional music production of all kinds there is generally some sort of team effort. There is usually too much to do and not enough time for one person to finish the job in time. This was never my experience working in my own home studio where I am master of my domain, doing it all on my own.

Everyone's work affects everyone else's on a project, which can tend to amplify mistakes and problems. As there are no standard texts or techniques for accomplishing many of the tasks described in this book, people often have some very different ideas and approaches to getting a job done. This can lead to some major catastrophes if, for example, someone "assumes" how someone else needs a tape prepared.

There is also a real lack of in-depth information available to the beginning amateur and semi-pro musician trying to learn how to get the most from his or her equipment. Now that the "bedroom recording/post-production facility" is a reality—thanks to an extraordinary boom in low-cost musical technology—there is a need for better information about how it is all used. It is no longer enough to understand how each piece of equipment you own works. That is essential, of course, but the next level—how all of it connects—is also of vital importance. Not just how to use MIDI—there are a number of good sources of information on MIDI—but how to *link* sequencers, drum machines, tape recorders, video decks, automated mixers, sound effects, and computer programs together into a system to do ANYTHING.

This book covers a wide range of musical and technical topics. If you are a musician, you will learn the inner workings of recording and audio/video post production. You will need to know this information if you plan to work in the areas of film, video or multimedia production. If you are already working in this field, you may have already hit some major snags somewhere along the way while trying to get your musical ideas to match the picture on the screen. In this case, you will find out just how and why these problems can happen and how to avoid them in the future. You will learn ways to help make working in any recording studio (including your own) go smoothly. If you are involved in other aspects of film or video production and want to understand how musicians and composers work within the media of film and video, that too is explained in detail.

Anyone putting together a home or professional recording studio needs to know about the equipment necessary to synchronize all of their MIDI and non-MIDI gear together with multitrack, stereo tape machines and VCRs. By understanding the problems involved in doing musical work at home or in a studio, you will see how various brands of "black boxes" offer specific solutions. Some systems may answer your needs better than others, and may also offer you better options for growth in the future.

Jeffrey Rona
1990

INTRODUCTION

The world of contemporary music-making has changed radically in the last few years. A whole new technology is in place and thriving. It is helping an enormous number of musicians to see their ideas come to life on record as well as on the big and small screen. A by-product of this technological explosion is an increasing number of choices in techniques and equipment. The home recording studio has become a viable means of professional music production, and there is an entire class of electronic products geared for this group of musicians.

This book is by no means an exhaustive explanation of the techniques used in either the recording studio or on the film dubbing stage. You will find a list of other resources in the appendices if you want to explore these subjects further. The technique and aesthetics of composing for film or television could easily fill a book much larger than this one. But here you will find ample explanations of those parts of composing and recording that depend on electronic music systems and technology in order to flow from the mind's ear to tape.

"In the beginning was rhythm."

Hans von Bulow
Machlis, "Introduction to
Contemporary Music" (1963)

Chapter 1

OF TEMPOS AND TIME BASES

WHAT IS TEMPO

usic is a temporal art. It exists in time and can only be expressed over a span of time. Unlike painting, sculpture, or other plastic arts, music has duration and pace that cannot be specified by the observer. The pace of a piece of music or a segment of a piece of music is called *tempo* (Italian for "time"). Traditionally, the pace of music is broken down into regular intervals of time called *beats*. Tempo can be specified as the number of beats occurring in a given period (usually a minute). Tempi (the correct plural of "tempo" for you Latin fans) range from very slow to very fast. Italian is the language traditionally used in music scores to indicate tempo, though some English-speaking composers opt for English (and why not?).

Here are some of the most commonly-used tempo markings, in order from slowest to fastest, along with the typical range of each term in beats per minute:

grave (very slow, gravely)	35 - 45
largo (slow, broad)	42 - 56
larghetto (not as broad)	51 - 56
lento (slow)	40 - 56
adagio (slow, at ease)	58 - 69
andante (walking tempo)	72 - 88
moderato (moderate)	85 - 95
allegretto (slightly less than allegro)	90 - 110
allegro (fast, happy)	92 - 134
vivace (quick, lively)	134 - 172
presto (very fast)	172 - 216
prestissimo (as fast as possible)	180 - ??

Tempo markings in musical scores and on synchronization devices are assumed to be in beats per minute (BPM) unless specified differently. It is important to note that composers use these terms loosely, not as absolute tempo indications. The tempos in the chart above are estimates (your mileage may vary).

In addition to the regular pace of a composition, there are also terms for the increase or decrease of tempo:

accelerando (to speed up)
ritardando, or simply *ritard* (to slow down)

Once again, some composers will mark their music with indications in English, such as "speed up" or "slow down," though the Italian markings are most commonly used. Rarely do you see a contemporary musical score or chart with a tempo mark and not a specific tempo in BPM.

Rhythm

Tempo is not the only factor that determines the pace of a piece of music. *Rhythm* is the motion of events (notes) within a piece. This is different from tempo, although they are sometimes confused by both musicians and non-musicians alike. A piece of music at a slow tempo (like *adagio*) can be very rhythmically complex if each beat is broken into many parts, thus making the music sound fast with a lot of notes. Conversely, a piece of music may have a very fast tempo (*allegro*), but be very simple rhythmically and thus sound slow.

Typically, a beat is divided into 1, 2, 3, or 4 parts. Most music is written with beats grouped together into *measures*, each with the same number of beats. Most of the music you hear has four beats in each measure, which is called *common time*. The number of beats in a measure is used to define rhythmical terms. For example, notes that occur only once per beat are called *quarter notes*, since they divide a measure of common time into four quarters.

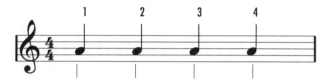

If every beat in a four-beat measure is divided into two equal parts (two notes per beat), the rhythmic value of each note is called an *eighth note,* since there will be eight notes in a four-beat measure.

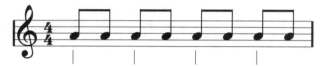

The rhythmic value that comes from dividing a beat (or quarter note) into four equal parts is called a *sixteenth note.*

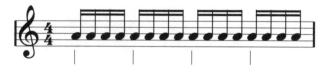

Of course there are also note rhythms that are less frequent than once every beat. Two notes of equal length in a four-beat measure are called *half notes.*

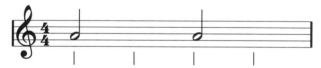

A single note can also fill the entire four-beat measure. These are called *whole notes,* since they take up the whole measure.

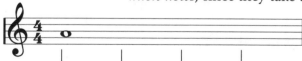

Rhythm divides time down into smaller chunks by way of sonic events. It is an essential element to music and musical style, and seems to even be a fundamental part of humanity itself.

THE STARTS AND STOPS OF MUSIC

Rhythm is about the "starts" of notes at a given tempo. However, just as "what goes up must come down," what "starts must also stop." In the case of most instruments, particularly those that play one note at a time, each note is begun on a beat or rhythmic subdivision of the beat and stopped at some point before the next note is started. Even with polyphonic instruments, such as the piano or synthesizer, notes begin directly on a rhythmic division of the measure but end at some later point in time that has little or nothing to do with the rhythmic subdivision of time.

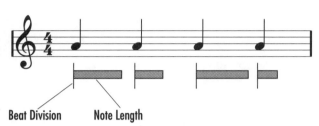

Beat Division Note Length

The duration between the start and end of a note is called *articulation*. Notes of any given rhythmic value can be long (extending to the next note), short (stopping quickly after it's started), or anywhere in between. There are almost unlimited ways in which a single note can be articulated. This is one of the key elements to a musician's style—the length of time each note of a phrase is held. So, while a note will typically begin at one of only a few places in a bar (the rhythmic subdivisions), lengths of notes are highly variable.

TIMEBASES

Trained musicians can easily keep a tempo running in their heads while playing a piece of music. For example, if a musical part calls for a string of sixteenth notes (four notes per quarter-note beat) to be performed, the musician divides the beat into four equal parts and plays a note at each of those four intervals.

In a sense, then, there are eight separate events taking place during this beat: four notes starting and the same four notes also stopping. The style and articulation (or "phrasing") of the musical passage will dictate the various lengths of time between the events. Four notes of equal duration could be played in a number of ways. For example:

Articulation (Length of note)

What if you wanted to come up with some very accurate way of measuring the durations of the notes in the above phrases? Measuring the "starts" of notes is easier since they usually occur on just a few simple divisions of the measure. You could measure them by dividing up the beat into many small, equal-sized slices, then counting how many slices there are between the note's starting and its ending.

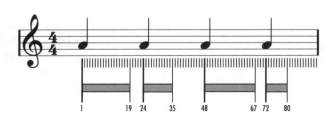

It should start to become clear that the smaller the slices used to divide time, the more accurately it can be measured when events occur. You need to find an appropriately small unit of time with which to perform your measurements. If you tried to measure out material for a suit with the mileage meter on your car, there's a good chance it might not fit. The smaller the units of

measurement, the more accurate the measurement. Chemists, physicists and engineers use inconceivably small units of measurement in order to accurately judge the things they study.

It is the same with musical events. In order to accurately record and reproduce events in time, you need to use sufficiently small units of time. How small is small enough?

millennia
centuries
decades
years
months
weeks
days
hours
minutes
seconds
half-seconds
tenths of seconds
hundredths of seconds
thousandths of seconds
very, very small parts of seconds

Only Time Will Tell

In a song with a tempo of 60 beats per minute, each beat lasts one second. If the tempo is doubled to 120 beats per minute, each beat will be a half a second long.

quarter note = .5 second (1/2 second)
eighth note = .25 second (1/4 second)
sixteenth note = .125 second (1/8 second)

If the tempo is increased to 145 beats per minute, the lengths of notes become shorter:

quarter note = .41379310344828 second
eighth note = .20689655172414 second
sixteenth note = .10344827586207 second

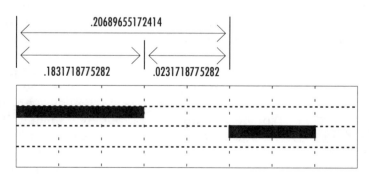

.20689655172414

.1831718775282 .0231718775282

Tempo = 145

The time values above represent the full lengths of the beats themselves. They do not take into account that there are two events in each note that must be timed: The time between the beginning and end of the note (the articulation) and the time until the next note begins.

So, even something as simple as eighth notes at a tempo of 145 BPM would require a very precise clock to measure the times between events accurately.

HOW IT'S DONE

One way to measure musical time would be with a clock similar to a stop-watch. Think of it like timing the runners in a footrace as they come across the finish line: Whenever a runner crosses the line, you record the time on the watch when the event happened. Normal clocks (like a stopwatch or the one on your wall) run at one speed, regardless of what they are being used to time. Even an egg timer, which is reset to time new events (dropping another egg into the water) runs at the familiar pace of minutes and seconds.

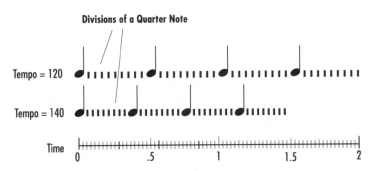

However, this is not the way musical events are measured by the vast majority of electronic music systems. Instead, they are measured with something called a *timebase*. A timebase is an electronic clock that varies its speed to match the tempo of the music. The faster the tempo, the faster a timebase clock will run. The advantage of timebases over the "stopwatch" approach is that by changing the speed of the clock, all the musical ratios stay the same.

Musical devices such as sequencers, drum machines and synchronizers all have clocks in them to determine the tempo of the music playing. The tempo controls on these devices govern the rate of the timebase—faster or slower. Thus, timebases divide music up into very small slices of time. The size of a timebase's slices is up to the makers of the individual devices. *The smaller the slice of time, the more slices per note, and more accurate the measurement of musical events.* A timebase with a larger number means it is measuring time more precisely.

How timebases are used in clock-based musical devices, and how these devices can share this clock information is covered in the next chapter.

PPQN

Tempo is measured with basic units of time called *beats*. Beats are grouped into slightly larger units called *measures*. A measure is a group of beats, with the first one usually having an accent, or stress. Typical measures have between two and four beats, but they can have as many as the composer desires.

The faster the tempo, the faster the beats move by. Therefore, in measuring the starts and stops of music, the faster the clock (timebase) needs to go. As mentioned earlier, a note which lasts for one beat is called a quarter note, since it divides the average measure of four beats (common time) into quarters. For electronic musical devices, the timebase that divides up time into small slices—a *synchronization signal* (or sync signal)—is a pulse of electricity. It looks like Figure 1.1.

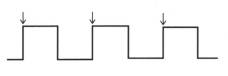

Figure 1.1
Sync signal

The pulse wave rises and falls a specific number of times each second, depending on the timebase used. Because this sync signal is used to represent the timebase of a device, its rate will vary depending on the tempo of the music. Instead of being measured in cycles per second, the timebase is measured by the number of times it occurs each beat, or quarter note. It is therefore referred to as *Parts Per Quarter Note* (PPQN or PPQ for short). If the timebase of a particular instrument divides a beat into 96 parts, that is called 96 PPQN.

Some synchronizers for musical instruments have one or more outputs called "clock out" or "timebase out" on them. These output the square wave shown in Figure 1.1 at approximately 5 volts, called a "TTL level" which stands for Transistor-Transistor Logic. In order to use a clock-based synchronizer, a sequencer or drum machine must have a "Clock In" jack for accepting external clock signals with which to synchronize its performance. As MIDI (Musical Instrument Digital Interface, covered in the next chapter) has gained in popularity, the use of electric (analog) clock signals has diminished. But as there are a large number of devices still using non-MIDI types of sync signals, timebase-oriented sync boxes still play a role in many production situations. There are sync boxes that convert timebases to or from MIDI timing signals in order to operate pre-MIDI equipment with newer MIDI devices.

THE FINAL RESOLUTION

There is no single standard timebase for musical devices or software. Timebases may vary from as little as 24 PPQN to 480 PPQN and much higher. You will rarely, if ever, see the timebase written on the instrument itself, but this information should be in the user's manual. Higher timebases will record the timings of musical events with greater accuracy (preserving all the original musical nuances), although even one as low as 96 (a typical one) does a fairly good job. Certainly one selling point for any electronic musical device is a clock with a higher resolution.

Composition
Movement
Theme
Phrase
Measure
Beat
Note
Fraction of a Note

If you are working with a number of non-MIDI devices that use clock signals, you will need a synchronizer capable of generating the timebases you need. They are called *timebase converters* and are readily available. A number of the more sophisticated tape synchronizers have options for multiple timebase clock outputs.

MIDI SYNCHRONIZATION

MY INSTRUMENT DOES INTERFACE

IDI (the Musical Instrument Digital Interface) is a means by which various electronic instruments can be connected by a common cable and operate together as a system. It has changed forever the way that music is made. MIDI communicates musical information in the form of a special digital computer code using a common cable with five-pin DIN plugs at each end.

Instead of functioning in the audio domain, MIDI sends and receives *performance information*. For example, when a key is pressed on a MIDI synthesizer, the instrument instantly sends out a digital code indicating which key has been pressed and how quickly it was pressed. Any other MIDI instrument connected to the sending keyboard will begin to play the same note just as if its own keyboard had been used to play the note. It will also reproduce the dynamics with which the note was played. In addition to notes, MIDI instruments can send information about changing sounds, bending the pitch of notes, adding vibrato and other expressive elements, and most everything else about the way an instrument is played. Actions performed on one instrument are sent to and reproduced by any other instruments connected to it. Some of the messages that can be sent from one MIDI device to another are:

MIDI IN

5-pin DIN plug

- ☿ **Notes**—Sent by pressing a key on a MIDI keyboard, plucking a string on a MIDI guitar, hitting a pad on a MIDI drum kit, or blowing into a MIDI wind controller.

- ☿ **Sound changes** (called "program changes")—Sent by pressing a "patch memory" button on an instrument.

- ☿ **Expressive pitch bending**—Sent by moving a lever or a wheel.

- ☿ **Vibrato** (called "modulation")—Sent by moving a lever or wheel or by pressing down hard on a key after it has been struck.

- ☿ **Sustain pedal**—To sustain notes after the keys have been lifted, sent by stepping on a pedal just like on a piano.

- ☿ **Synchronization**—The clocks in sequencers and drum machines can be locked together with the same MIDI cable that sends the other parts of the music.

MIDI has become a universal standard among makers of electronic musical instruments. Unlike the "standards" found in some other industries, MIDI is a truly universal musical language. Instruments of any brand, model or price range

can be connected into a single network and operated in a similar manner. MIDI is simple to use, but its simplicity does not prevent it from being extraordinarily powerful and flexible. (For more complete information about MIDI, see my book "MIDI: The Ins, Outs & Thrus" also from Hal Leonard Books).

THE SYSTEM

MIDI devices are connected together into musical systems that can be made up of a few or many components. For example, a simple system for composing music might look like this:

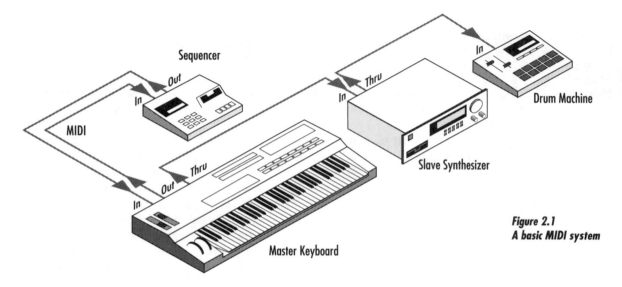

Figure 2.1
A basic MIDI system

The keyboard is a master controller for the system. Anything performed on its keyboard goes from the instrument's MIDI Out jack to the sequencer's MIDI In jack. The sequencer can pass that data on to any synthesizers in the system, which will respond by playing exactly what is played on the master. The sequencer also records all incoming notes and rhythms by measuring the time between the musical events (as described in the explanation of timebases in the previous section). On playback, the sequencer can then send MIDI messages back to the master keyboard's sound-producing circuitry as well as to any and all additional instruments that are connected to the system.

Unlike an audio recorder, a sequencer does not record sounds. It records MIDI commands. The commands are generated by any MIDI instrument as it is being played. It works much the way a player piano does, noting which keys are played and when, then commanding the instruments to replay the recorded performance on playback.

There are a number of advantages to this over strictly audio-based recording:

- The amount of data that is transmitted by MIDI instruments to be recorded into a sequencer is very small compared to audio signals (digital or analog) which helps to make the system much more affordable.
- Since the instrument's sounds themselves are not recorded, they can be changed without needing to re-perform the music.
- The tempo can be changed without changing the pitch.
- The pitch (key) can be changed without changing the tempo.

- ✦ Editing and changing musical material is simple.
- ✦ A single low-cost sequencer can be used to simulate many aspects of an expensive multitrack recording system.

BUT WAIT, THERE'S MORE!

Not only can a synthesizer control another synthesizer, but it can also have its MIDI data be recorded into a sequencer and played back. Simple. But how does a drum machine fit into all of this?

In addition to the messages sent over the MIDI cable to indicate that notes are to be played, there are other codes that are not intended to trigger notes, but to synchronize the performance of any MIDI clock-based machines.

These commands are called *System Real Time* messages, and are used exclusively to synchronize the performance of any MIDI devices in which there are clocks. In Figure 2.1, there are two clock-based devices: the sequencer and the drum machine. Via the MIDI cable that connects the two devices, the master (the sequencer in this case) can command the slave unit (the drum machine) when to start, when to stop, how fast to play, whether to start at the beginning of a song or from the most recent stopping point. All of this is accomplished with the following four MIDI commands:

✦ MIDI Clock

Any MIDI device with a clock in it (including sequencers, drum machines, computers running MIDI software, etc.) sends out this code at a rate of 24 PPQN. The faster the tempo setting is on the device, the faster this code is sent. Any other clock-based devices connected via MIDI will receive the messages, detect the exact tempo setting and know if it ever changes. In this way, any number of sequencers, drum machines and computers can be linked up and run at the same tempo.

✦ Start

When you press PLAY on a sequencer or drum machine, the device will send out the *Start* command to tell all the other clock-based devices to start playing from the beginning of the song.

✦ Continue

You may not always wish to start at the beginning of a song when you are playing a MIDI sequence. As opposed to the Start command described above, *Continue* tells a device to play from wherever it last stopped. This way you can press STOP and CONTINUE on a sequencer at any time in a song, and the other slaved units will follow right along from the same places in the music.

✦ Stop

You may not always want to listen to something all the way through. When you press the STOP button on a drum machine or sequencer, it sends out this command to tell all of the slaved devices to stop.

With these few commands, MIDI allows a musician to set up a musical system using virtually any piece of electronic equipment available today. Furthermore, with the use of some other simple devices, described in detail later in this book, MIDI systems can be locked to multitrack tape or video with great ease. The next section shows how a MIDI system is put together and locked up "tight as a drum."

LOCKING SEQUENCERS AND DRUM MACHINES TOGETHER

SEQUENCERS ARE PEOPLE, TOO

There is little question that the MIDI sequencer has changed what is happening in recording studios and in musician's homes everywhere. This power can have an enormous effect on the ways music is made, making it easier, faster and allowing the best possible performances to get onto the final recording. Of course, sequencers and MIDI equipment do not replace recording equipment. The final "product" (a very "industry" term meaning "music") must still be in a standard recorded format for playback on a record player, cassette, CD, DAT, laser disk, video machine or film (was anything left out?).

A MIDI sequencer is able to record incoming MIDI information and replay it with great accuracy. It can also be either a master clock or a slave to other devices. Thus, a sequencer can be made to follow other sequencers, drum machines, or tape synchronizers. This is done through the use of MIDI's System Real Time synchronization commands (Start, Stop, Continue, etc.).

SEQUENCERS A LA MODE

Inside every MIDI sequencer is a clock. The speed of the clock can be changed to affect the tempo of the music that the sequencer has recorded. Sequencers can also be set to synchronize with the clocks in other instruments that are connected to it via MIDI. This is usually called *External Mode*, *MIDI Sync Mode* or just plain *MIDI Mode* in the parlance of most sequencers. In any case, they all mean the same thing: Instead of using its internal clock to set the pace for recording and playback, the device is "slaved" to the clock inside another sequencer. When the "master" sequencer starts, so will the "slave" machine set to its MIDI sync mode. It will run at exactly the same tempo and will stop whenever the master device is stopped. In essence, although you are using two separate machines connected with a MIDI cable, they behave and perform as a single device.

While it is not often that two sequencers will be connected together (one should usually suffice, thank you), it is very common to connect a sequencer with a drum machine. A drum machine is really a specialized sequencer with drum sounds built into it. It operates in the same way as a standard MIDI sequencer, recording parts into its memory and playing them back. In a typical system, one drum machine is connected to one sequencer. The drum machine is placed into its external sync mode so that it synchronizes its performance to the sequencer's clock via MIDI sync codes. The slaved drum machine will start and stop in exact sync with the master sequencer, and will run at its exact tempo as well. In es-

sence, the two units become a single device, controlled from the one set of controls on the master sequencer.

Of more importance than running multiple machines together—good for composing, live use and occasional studio applications—it is vital that sequencers have the ability to slave to other more physical devices such as tape machines and video recorders in order to synchronize their performances to tape tracks and motion pictures. In this way, the digital "virtual track" world of MIDI sequencers can be married to the physical world of tape machines and video recorders. There are a number of ways that this can be done, but in essence they all accomplish the same thing: They replace the internal clock of the sequencer with an external clock source. MIDI is one way of providing sync signals for sequencers. But MIDI codes cannot be recorded onto tape directly. Fortunately, other means of recording clock information on tape and video are available.

SONG POSITION POINTER AND SONG SELECT

In addition to the MIDI synchronization commands described in the previous section, there are two additional MIDI commands that add a great deal of power to a sequencing system using multiple devices. They are called *Song Position Pointer* and *Song Select*. They are in the group of MIDI codes called *System Common* messages since they affect every device in the system.

SONG POSITION POINTER

Often, when working on a sequence you may wish to listen to a section of music from the middle of the song. Most sequencers can do this by "locating" to that measure, just as though you were fast-forwarding on a tape machine (except there is no waiting for the tape). This speeds things up considerably since you don't have to always listen from the beginning of the song.

If a drum machine or another sequencer is slaved to a master sequencer, it would be awkward to have to set each unit to the desired measure before pressing the START, CONTINUE, or PLAY button. This was taken into account when MIDI was created by including a special "auto-locate" command called *Song Position Pointer*. As with most of MIDI, you don't need to know how Song Position Pointer (or "SPP") works or how to use it. All that matters is that the devices you are using implement it.

Sequencers and drum machines keep a running count of the number of sixteenth notes from the beginning of the music, whenever they play or record. Hitting STOP causes the machine to hold onto this number, called the "song position." When START is pressed, the song position is reset back to zero and the music plays from the beginning. By pressing CONTINUE (as most sequencers and drum machines call it), the music continues playing from the point at which it last stopped, and the song position continues counting sixteenth notes.

When the song position (or "location") is changed on the master sequencer, the sequencer will send out a SPP code to tell all slaved devices where in the song to locate. This value is in sixteenths from the start of the music, so instead of expressing the new location as "bar 7, beat 2," a Song Position Pointer will say "go 120 sixteenth notes into your sequence." The slaved units locate their internal song pointers to that same location and wait for the MIDI Continue command to be received, at which time they will begin to play from the current song position. SPP can only be sent while a sequencer is "idle"—not playing or recording.

Occasionally, sequences played from points other than the beginning can turn up sounding quite different than the way they were played. This is because starting at an arbitrary point in the middle of a song can skip some crucial MIDI commands. For example, a track with patch (sound) changes in it will not send the commands to call up the correct sound before playing commences. If a sustain pedal, pitch wheel, modulation wheel, or other MIDI controller was started previous to the song position, it will not be triggered. Notes that should sustain won't, and notes that should bend or modulate will not either. If, for example, a chord is started in bar 4 and held for 10 bars, it will not be heard if the song is started after bar 4. This is one of the drawbacks to working with MIDI, but it seems to be a small price for the power and ease it provides. These problems will not happen when the sequencer is played from the beginning, as when the sequence is recorded.

Another small problem with Song Position Pointer can occur when working with some drum machines. Drum machines all work on the principle of creating a library of short patterns of two or more bars in length, and then linking the patterns together into a song. Often, while composing music, you may work with a drum machine in its "pattern mode," simply playing one pattern over and over as a rhythmic reference. While they work fine in their "song mode," drum machines may misinterpret or simply ignore Song Position messages while in their pattern mode. This may cause the drum machine and sequence to sound out of sync, but the problem will not occur either when starting from the beginning of the song, or after chaining the patterns in the drum machine into a song.

You will be relieved to read later on that SPP also works with a number of tape sync devices for audio and video, so that a sequencer slaved to tape can still use SPP to locate to different points within the music and play in sync.

Song Select

There is another, much less-used MIDI sync function for linking multiple sequencers and other clock-based devices together. It is called *Song Select* and it works similarly to a jukebox. It allows sequencers or drum machines that are capable of holding multiple songs in memory at once to select which song to play next. As with SPP, it can only be sent or received while the device is not playing or recording. Its greatest benefit is in on-stage use, where selecting a song on the master sequencer will command any other devices connected via MIDI to go to that same song. However, there are only a few sequencers currently available that hold multiple songs simultaneously.

Transferring Data Between Sequencers

In addition to coordinating the clocks of sequencers and drum machines, and synchronizing them to tape, there are other useful applications for synchronization in the studio. Sequencers, like the people that use them, have distinctive personalities. From time to time, there may be reasons to take tracks recorded with one sequencer and transfer them to another. For example, two people with different sequencers may wish to collaborate on the same music, or a sequencer used to do the first tracks of a song is not sufficiently powerful to finish the job, and another sequencer is used to replace it.

Another very useful technique is the transferring of rhythm parts from a drum machine to a sequencer, allowing them to be edited simultaneously with the rest of the music. (As you'll recall, a drum machine is really just a sequencer with drum sounds built-in.) Also, while many of the computer-based sequencers

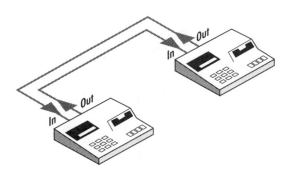

Figure 3.1
MIDI sequencers connected together to transfer music.

are of very high quality, they are not much fun to take on the road, to a club or to a studio (do you want to give your new color monitor to a roadie?). A simple solution is to transfer the sequences from your computer to a small, portable sequencer and leave the computer at home. The connections and synchronization techniques required to accomplish any of this are very simple.

In the Figure 3.1, two sequencers are connected together, the MIDI Out of each going to the MIDI In of the other. The music data from either sequencer can now be transferred to the other machine. Here is the procedure:

✪ One unit must be a master, while the other is slaved to it. It doesn't matter if the master will be the sender or the receiver. To be a slave means to be put into "MIDI Sync" or "External" mode while the master will remain in "Internal Sync" mode (different sequencers use different terms to mean the same thing). There is usually a button or function on the front panel to set the sync mode for the machine.

✪ The sender is set to play back one or all of its tracks. If you want to keep the tracks separate as they were in the original sequence, then the tracks may need to be transmitted one at a time (unless the receiving sequencer can split tracks up based on MIDI channel).

✪ Assuming that the receiver (the one recording the data) has been placed in external sync mode, it will wait for an incoming MIDI Start command after its Record button has been pressed to begin recording. This will be sent by the sending sequencer upon pressing its Play button.

✪ If the sender is to be the slave, set it to external sync mode and leave the receiver in internal sync mode. When the Play button is pressed on the sender, it will wait until a MIDI Start command is received. Pressing the Record button on the receiver will send the MIDI start and begin recording as well.

✪ The track or tracks are transferred from the sender to the receiver. There is no reason to do the transfer at the correct tempo of the music, especially if it is at a slow tempo. You can turn up the speed on the master sequencer (since it dictates the tempo for the transfer) in order to save time. Don't go too fast, though, or some of the data might be lost and the timings may change slightly. Some sequencers can handle fast data better than others. Try a few bars and play it back on the receiver to check. You will be surprised at how quickly data can be transferred between machines. Press Stop on the master device when the transfer is finished.

✪ After the first track is transferred, repeat the process with all the additional tracks. You may wish to mute the playback of the tracks on the receiver to allow for faster transfer with less chance of error.

✪ If you are only transferring data in one direction, you can get by with only one MIDI cable, going from the MIDI Out of the sender to the MIDI In of the receiver. The sender must be the master in this case, with the receiver being set to its MIDI Sync or External mode. There may occasionally be a problem with the hardware, such as the receiver not recording well in sync mode, or the sender not transmitting MIDI sync codes properly (which can be the case occasionally). In these cases

19

using a second MIDI cable and switching the roles of master and slave will usually help.

Computer-based MIDI sequencers can exchange music sequences by means of a universal file format called a *Standard MIDI File* (SMF). This standard was jointly developed by the makers of sequencing software to allow for the easy exchange of music files between any brands of sequencers as well as other musical software, such as music transcription programs. All tempo information is included along with the music, so music should sound virtually the same from one sequencer to another.

Expressive Sequence Transfers

The reason that sequencers are synchronized for transfer is so the bar numbers in one system will match the bar numbers in the other. As far as the notes themselves are concerned, the receiving sequencer doesn't know if the incoming notes are from a sequencer or simply from a person playing directly from a keyboard. One interesting trick is to refrain from synchronizing the sequencers during transfer and thus create tempo changes which are stored in the sequence. The technique is simple: With both units in their Internal Sync mode, press Play on the sender and Record on the receiver simultaneously. At any appropriate time, change the tempo of the sender up or down to create expressive tempo changes. All of these tempo changes will be recorded and memorized by the receiver automatically. The drawback to this is that the measure numbers in the sender will not match those in the receiver. But if you have a finished sequence, perhaps one designed to accompany a live performance, you can add a sense of "human feel" and expression to the music with this technique.

Talking Drums

As mentioned earlier, drum machines are a type of sequencer with sampled drum sounds built into them. Most drum machines operate in one of two modes: Pattern and Track (or Song). Because of their repetitious nature, drum parts consist of a number of individual rhythm patterns that are linked together to create a "song" (sometimes called a "track" on certain machines).

MIDI drum machines assign MIDI note numbers (each note in MIDI is given a number) to the trigger buttons on their front panels. A bass drum might be C (MIDI note number 36); a snare, D; the hi-hat, F♯, etc. While the drum machine is playing, these note numbers are sent though the MIDI Out of the machine. Conversely, when the drum machine receives one of these note numbers through its MIDI In, it will act like any MIDI synthesizer by playing the corresponding drum sound.

Individual patterns or entire tracks can be transferred to a sequencer from a drum machine in exactly the same manner as between two sequencers, as previously outlined. The sequencer then sends MIDI note messages that are used to trigger the sounds in the drum machine just as it would any other synthesizer. This eliminates one need for sync between a sequencer and drum machine, since you will no longer be using the drum machine's internal clock or sequencer. Music edited in the sequencer can simultaneously modify the drum parts as well.

What's The Catch?

MIDI sequencers have probably added more power to the recording studio than any other technological advance since the advent of multitrack recording. While their advantages are numerous, there are limitations and headaches that sequencers alone can provide:

☮ Without a sufficient number of synthesizers, sequencers are "all dressed up with no place to go." Thus, in order to gain the power needed to make music of more than modest complexity, you do need a number of instruments.

☮ Sequencers add no functions to a synthesizer they do not have to begin with. If the synthesizers you are using are only capable of producing a single timbre at a time, then that is all you can get with a sequencer as well.

☮ Standard MIDI sequencers can only record the synthesizer parts of a song. They do not take the place of an audio multitrack recorder for recording voices or other acoustic parts of the music. Some MIDI sequencers do provide digital audio capabilities, but at a much higher expense.

☮ Sequencers rely on synthesizers, drum machines and other signal processors to realize music. Each time you return to a composition to continue work on it, you must reconfigure each part of the system exactly as it was at your previous work session. MIDI itself has no way of configuring a studio, making it difficult to reproduce exactly timbres and mixes from previous sessions. Careful note-keeping is essential to be able to pick up where you left off on a previous session.

To a degree, these complaints are the devil's advocate. MIDI sequencers are wonderfully useful, practical, powerful devices that more often than not enhance most any music production situation. Sequencers are at the heart of the electronic music studio, but require support hardware to function most efficiently. The ability to combine them with audio and video tape equipment can eliminate a number of the problems mentioned above. In the next section you'll begin exploring the ways to accomplish synchronization with the "real world."

CLICKS

What student of music hasn't learned to hate this device? The metronome was invented by one Mr. Dietrich Nikolaus Winkel around 1812 in Amsterdam, but the idea was stolen and made popular by Johannes N. Maelzel. In fact, the device was called the Maelzel Metronome at first, and tempo markings on music scores are often noted as "M.M." for "Maelzel's Metronome."

Metronomes are used to produce a steady audible click in order to maintain a given tempo while practicing music. They are calibrated in beats per minute (BPM) and typically have a range from 40 to around 240 BPM. All personal childhood grudges aside, they can be invaluable in helping a musician or ensemble keep a steady and consistent tempo from the beginning to the end of a song. They can also be used to keep groups of musicians "in the groove" if everyone listens to it while playing.

THE CLICK TRACK

Click tracks play a vital role in a number of recording situations. Although musical ensembles have gotten along fine with conductors for the past few hundred years, many pop and film recordings today keep precise, unvarying tempos for lengthy periods of time. Forgetting about purely electronic, machine-produced music for a moment, any music that requires a very accurate tempo, such as film music, or a perfect, constant beat, such as pop or dance music, requires a click to serve as a guide for the musicians. Even bands and artists who "groove" well in live performance often rely on a click track in the studio to achieve a "perfect take" tempo-wise. With the right equipment, clicks can also be used to synchronize sequencers to a tape machine. In fact, this was the main synchronization technique used for many years, though better systems for machine synchronization have become more prominent.

The decision to use a click track for a recording should be made on a song-by-song basis. While about 90% of the pop music and 99% of the film music recorded today is done with clicks, there are certainly cases where a click track may not be appropriate, such as slow ballads or music with expressive tempo changes (the musical term is *rubato*). Having a band or ensemble play to a click provides an absolute reference for the beat, which can resolve disputes about notes being played ahead of or behind the beat by any player. If the decision is made later on to add sequenced electronic parts, the click track can provide the sync reference needed to synchronize the sequencer's performance with the tape.

THE GOOD CLICK

Virtually anything with a percussive audio output can be used as a source for clicks. If the clicks are to be used only for musicians ("liveware"), they can be produced with a metronome, any sound from a drum machine, or from a programmable sync device capable of producing clicks. The sound used for a click should be short and distinct. Metronomes that generate a "beep" instead of a "click" should be avoided, since they are much harder to hear over the music. Clicks can either be played live to the musicians while they are recording, or they can be recorded onto tape and played back into the musicians' headphones.

RECORDING CLICKS TO TAPE

The most convenient way to use a click machine is to record its audio output to a track of the tape before starting on any of the music tracks. Another technique, although somewhat less desirable, is to record another type of sync signal onto the tape (such as FSK or SMPTE, described later) and use it to synchronize a click device "live" by sending the sync signal to the device's Clock Input. While this technique opens an extra track (since you won't need tracks for both click and another sync signal) it is somewhat more vulnerable to error. There are times when a click and another sync signal must be used, such as for recordings with both musicians and sequencers. The best techniques for this situation are covered in detail later.

TEMPO, TEMPO

Before a click can be recorded, the tempo of the music must be determined. It is almost impossible to make a change in tempo once recording of the music has begun. If you are working with film or video, the tempo will be derived from an analysis of the scene being scored. If you are working on an audio-only recording, then select your tempos carefully before recording clicks or other sync signals.

A ONE, AN' A TWO... (COUNT-INS)

Unlike a sequencer, musicians require a *count-in* in order to start playing at the very beginning of a song. A count-in is a sort of "running start" that lets everyone in a group know the tempo and where the first beat will be before the music begins. Count-ins are edited out of recordings, but you've undoubtedly been to a concert or heard a group in which somebody on stage calls out "1!...2!...3!...4!" When recording clicks, be sure to record one or two extra measures for the count-in. Also, include some extra clicks at the end of the music in the event that some changes are made during the recording that add beats to the music. If you are unsure about the overall length of the piece, including an extra minute or two of clicks is not a bad idea.

The length of the count-in is determined by the tempo of the music. Many composers and engineers routinely add a two measure count-in to all the music they record. In most cases this is fine. Everyone has a chance to prepare and to get a feel for the tempo. If the tempo is slow, however (anything below 90 BPM), waiting out those two measures can become a real annoyance after a number of

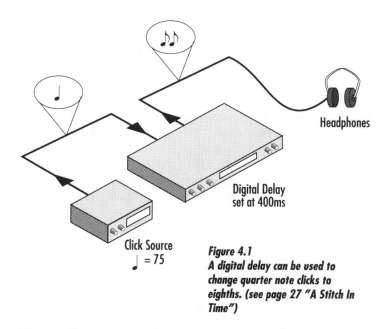

Headphones

Digital Delay
set at 400ms

Click Source
♩ = 75

Figure 4.1
A digital delay can be used to
change quarter note clicks to
eighths. (see page 27 "A Stitch In
Time")

takes. A one-measure count-in is prefer-able for slower songs. Make a note on the track sheet that goes with the tape as to the length of the count-in. On music with a very slow tempo (65 BPM or slower), it is often difficult to get a feel for the tempo even with a two measure count-in. To avoid this difficulty, a good trick is to either record an eighth note click, or to put the quarter note click through a digital delay with a setting that will produce eighth note or sixteenth note clicks. See Appendix B for the delay settings (in milliseconds) to do this.

Tape Level

When working with clicks on tape, it is of utmost importance that they do not leak onto other tracks of the tape and thus end up in the final mix. Multitrack tape machines all exhibit some degree of "leakage," or "crosstalk." This means that the audio signals recorded on one track can be heard faintly on the adjacent tracks. The first way to avoid this is to record clicks at reasonably low audio levels, in the range of -10 to -20 VU (VU stands for *volume unit*; it is one of the ways that the level meters on tape recorders are calibrated). The click should be as quiet as possible without getting lost altogether in the background tape hiss. If playback of the click is hissy because of low recording levels, you may wish to run it through a noise gate and adjust the threshold level to eliminate the tape noise completely. If the click is being used to drive sequencers and not just as a reference for the musicians, you may wish to record it at a slightly higher level to ensure that no clicks get lost.

Digital multitrack recorders have special auxiliary tracks for recording time code and clicks. These neither use nor leak onto the tracks for music, leaving all of the standard audio tracks available for music and other sounds. Levels for the sync signal and click can be much higher than for analog systems.

A Good Track Record

The best place to record clicks is on an "edge track" of an analog multitrack tape machine. On a 24-track recorder, the best track to use is 1 or 24. On a 4-track machine use either track 1 or 4. If you plan to have both a sync track (for the machines) and a click track (for the musicians), you can certainly record them on adjacent tracks with the sync track on the outside track and the click track next to it. A properly recorded click track will not leak noticeably over to the sync track. You should use the auxiliary tracks on digital multitrack recorders for sync signals and clicks.

It's a good idea to leave the track adjacent to the click or sync signal blank, if possible. Once again, this is to avoid the possibility of the click or sync signal leaking onto any of the music tracks. If there are not enough tracks on your recorder to allow the luxury of an empty track (called a *guard track*) adjacent to

the click track, then select a part that is very loud (such as lead guitar, brass, etc.) or is heard very little (such as a background countermelody). Never record a solo instrument or vocal on a track adjacent to the click track.

Avoiding Too Much Of A Good Thing

As the number of musicians used for an acoustic recording increases, so does the possibility of the click getting into the final recording from headphones. Here are a few ways to be sure this never happens:

☮ When working with an ensemble of any size, be sure that all the musicians keep their headphones on whenever the tape is rolling. One of the most common sources of click leakage into microphones is from headphones left on chairs by musicians who do not play during a section of the score. Instruct all players to UNPLUG their headphones if they wish to leave during cues in which they are not playing.

☮ If a player wishes to slip one side of the headphones off his or her ear (some singers and instrumentalists feel that they can hear better this way), be sure he or she keeps the unused earpiece tightly against his or her head. If everyone wants to slide one headphone off their ear, pan the headphone mix completely to one side.

☮ A limiter or noise gate with "keying" (which uses one audio input to automatically adjust the level of another audio input) can be used to control the level of clicks going to the headphones in such a way that the click gets louder as the music does.

☮ The click from tape or any live source is fed into a limiter or noise gate device before going to the headphone mix on the mixer.

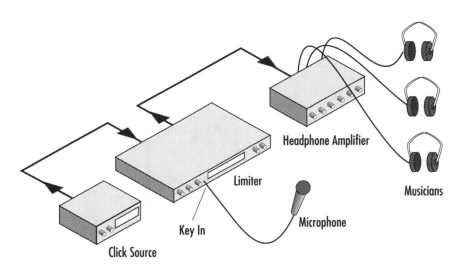

Headphone Amplifier

Limiter

Key In

Microphone

Musicians

Click Source

Figure 4.2
A technique to reduce
leakage during recording.

☮ A microphone (or monitor mix from the mixing board) is sent into the "key in" of the limiter.

☮ The limiter is then set to key the click with the audio level from the mix. Thus, as the level of the music rises, so does the "key," causing the click to get louder as well.

☮ The dynamic range can be adjusted on the limiter itself. This technique keeps clicks very quiet during quiet sections of the music, but still lets the click be heard by everyone during loud passages as well.

A note to conductors, or anyone who "counts off" vocally before the music begins: If you do a vocal count-in at the beginning of the music, never say the last beat number aloud. If you count four beats ("One, Two, Three, Four"), omit the last "Four" ("One, Two, Three, *silence*"). Count-ins can easily run into the first note of the music, making the process of mixing and editing to remove the offending verbiage much more difficult.

Using Click Converters

With the right equipment, clicks can be used as a clock source to synchronize sequencers and drum machines to tape. However, with the advent of more sophisticated and easier to use sync techniques, click is used less often to drive electronic musical devices in the studio. You may be called upon to work on a recording that was not intended to have sequencers or drum machine, and thus only has a click recorded on it as a tempo reference. In order to enable a click to drive electronic instruments, it must be converted into MIDI clock messages or another clock signal with a timebase that is compatible with your sequencer or drum machine. There are a number of devices available that perform this conversion. If you are planning to use click as a means of synchronizing tape and sequencers, be mindful of the following:

- Some click converters can accept a click and generate a clock signal or MIDI clock messages "live" (in real time), while others must first "learn" the click. "Learning" means that the click track is played one time from beginning to end into the converter without generating a sync signal from it. During this pass, the click converter times each click on the tape and looks for any tempo changes. After this is done, the click converter is set to its playback mode, and it will generate clock pulses or MIDI messages while reading the click again. Check the owner's manual of the sync device before trying to use it in this manner.

- A click converter may begin sending out clock pulses or MIDI messages from the very first click or may require a set number of clicks before starting the sequence. If you provide a count-in for the musicians, you must leave an equivalent space at the beginning of the sequence.

- Click converters can only play a sequence from its beginning. Some do have a "manual reset" function that lets you select any click to begin generating sync signals. By pressing the "reset" button just prior to the click on which you wish the music to begin, the converter will wait for the next click and then begin generating clock pulses or MIDI messages. Though the process is entirely manual, it is a simple and flexible technique.

- Some click converters available are designed and optimized for use with a live drummer or percussionist. They can calculate, with great accuracy, the current tempo from the rhythm being played. These devices can be used to integrate sequencers or drum machines with a live ensemble either in concert or on tape. "Live click" devices are not magicians, however, and can stray from the correct tempo during some fills or complex patterns.

"The means I find most serviceable as a guide to establish the tempo, are more convenient and cost so little effort to possess, for everyone always has it with him. It is the pulse beat of the hand of a healthy person."

Johann Joachim Quantz
Versuch einer Anweisung die Flote (1752)

A STITCH IN TIME (ADJUSTING TIME WITH A DDL)

An audio digital delay line (DDL) can be used to fine-tune the "feel" of a sequence that is synchronized with a click converter.

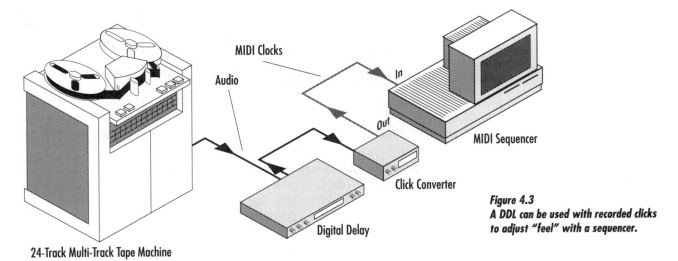

Figure 4.3
A DDL can be used with recorded clicks to adjust "feel" with a sequencer.

☙ Put one less beat of rest at the beginning of the sequence than the number of beats in the count-in. If the music has eight count-in clicks, leave only seven beats of space at the beginning of the sequence.

☙ Send the click from the tape to the input of a DDL, and from the output of the DDL into the click converter.

☙ Set a delay time that is equivalent to one beat (see Appendix B) and set the DDL to produce a single delay ("feedback" or "regeneration" = 0 on most DDLs).

☙ Do not let the original signal from the click track pass through the DDL. This is usually selectable on the front panel as "direct out" or some similar term.

The DDL will cause the click converter to receive its first click one beat late, and the delay will compensate for the missing beat of count-in silence at the beginning of the sequence. By making slight changes in the DDL's delay time, you can "slide" the sequence ahead of or behind the beat in very small increments of time. Some click converters have a noticeable lag in performing the click to clock (or MIDI) conversion. The ability to slide the music forward in time can fix this problem, if it ever comes up. Conversely, if the sequencer feels ahead of ("on top of") the beat, increasing the DDL's delay time can slide the sequencer parts back into the "groove."

Variations of this technique can be used with the other sync systems discussed later. Many sequencers have the ability to slide one or more tracks forward or backward in time. If this is available, there is no need for a DDL to adjust feel.

LOCKING SEQUENCERS TO TAPE

It's a common misconception that once the investment in adequate numbers of synthesizers, sequencers and other assorted electronic music paraphernalia has been made, the need for audio tape diminishes or vanishes altogether. What constitutes an adequate music system? The answer lies in the music itself. What does the music require for full sonic realization? The answer is usually "everything I own, plus one more instrument."

There are four primary reasons for requiring the ability to synchronize a MIDI sequencer and instruments to audio tape, and a number of secondary reasons as well. The main reasons are:

1. You can achieve bigger sonic textures by layering several instruments onto each musical line.

2. There are more musical lines than available instruments.

3. The music is not purely electronic in nature and other non-electronic instruments or voices are required to blend with the sequenced parts.

4. With a limited number of tape tracks (4 or 8), you may record only the acoustic parts, leaving the sequenced parts off the multitrack tape entirely. The sequenced parts are then synchronized to the tape and played "live" to be mixed with the recorded tracks onto the stereo master.

Sequencers, synthesizers and samplers are not yet ready to fully replace audio tape. There are tremendous advantages in working with a "hybrid" system in which the two are blended. There are many inexpensive, good quality multitrack recorders available in 4-, 8-, 12- and 16-track formats that can add a great deal of power and flexibility to a small studio. The techniques used to synchronize sequencers with these smaller units are no different than those used for the most extensive (and expensive) professional systems.

In all of these cases, nothing special needs to be done to the tape machine used in the system. Just about any tape machine will work. While some tape machines can be "slaves" in a system, they must have built-in special circuitry and additional hardware that is not within the financial grasp of most home studios. Instead, the tape machine functions as the master clock in a smaller hybrid system, and the sequencer becomes the slave, synchronizing its internal clock with a sync signal recorded onto the tape.

There are a few techniques used to link tape machines with MIDI sequencers and a number of them will be covered here. Some techniques are more powerful, but require some slightly more expensive hardware. But even these systems are affordable for most musicians and studios.

The end result in each case is the same: a stereo master tape.

FSK

FSK, which stands for *Frequency Shifted Keying,* is one of the simplest and least expensive forms of synchronization for electronic instruments. While rarely used anymore, FSK synchronization uses several principles that will be very helpful to understand later. Its strengths lie in its ease of use, low cost, and very solid timekeeping. Its main weakness is the requirement to always begin each overdub from the very beginning of the track. Here's how it works and how to use it.

The clock pulses used internally in instruments such as drum machines or sequencers are pulses of electricity used to represent the ticks of the clock. They would look something like this on an oscilloscope (an electronic graph of electrical or sound waves):

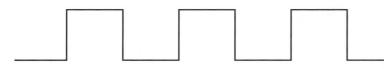

A square wave.

Most music devices that produce a clock signal use the standard TTL 5 volts from the bottom to the top of the pulse wave, which is a nearly universal standard. However, this level of electrical voltage cannot be recorded directly onto audio tape, which uses small fractions of a volt to represent an audio signal. The idea behind FSK is to assign a pair of audio tones to the low and high parts of the pulse wave signal. A high frequency means the clock signal has risen to its high point and a lower frequency means the clock signal has fallen to its low point. These tones can be recorded and played back from any tape machine with a *line input* and *output* (which are electrically compatible with audio devices, as opposed to microphones). They would look something like this on an oscilloscope:

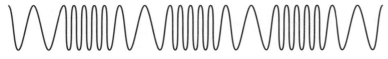

A modulated tone.

The devices that create and decode FSK assign two specific pitches to the high and low points of the clock signal. The specific frequencies of those pitches vary from manufacturer to manufacturer but are usually in the range between 1000 and 3000 Hertz (cycles per second). Unfortunately, FSK signals that use different frequencies are not compatible with each other. It is not unheard of for a few devices from different manufacturers to work together, but more often than not they don't. An *FSK converter* is needed to convert one type of FSK signal to another. One such device is aptly called the "FSK Adapter" (from Garfield Electronics).

FSK sync tones are created with special FSK sync devices, though a number of keyboard instruments with built-in sequencers have internal FSK generators and readers. Many drum machines and computer MIDI interfaces also have a built-in "tape sync" feature that uses FSK. Any of these devices can convert electrical clock pulses (or MIDI sync codes) into FSK signals to be recorded onto a track of a tape machine. Naturally, they can also convert the FSK signal back into clock pulses or MIDI sync codes that the sequencer will use internally to control the tempo of the music during playback. Again, these FSK tones may not always be compatible from manufacturer to manufacturer, or even from model to model by one maker.

One limitation of FSK is that, just like a click track, the tempo of the music must be decided before it is recorded. Once the sync track is created, the tempo cannot be changed without starting over again. Depending on the device used to generate the sync track, it is possible to have the tempo of the music vary over the course of the song, but once the FSK signal has been recorded on tape, the tempos will be fixed.

Using FSK

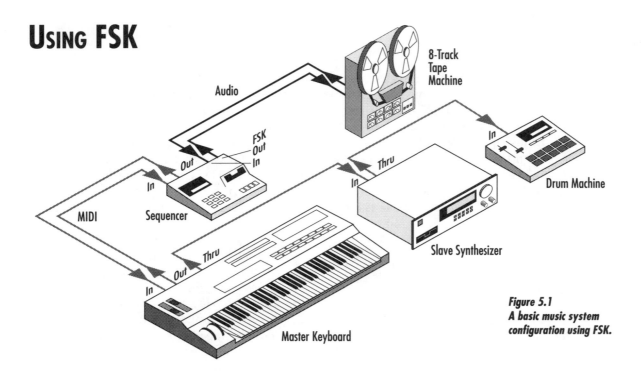

8-Track Tape Machine

Audio

FSK Out

Out In In

In

Thru

MIDI

Sequencer

Drum Machine

In

Thru

Slave Synthesizer

Thru

Out

In

Master Keyboard

Figure 5.1
A basic music system configuration using FSK.

Before any of the music can be recorded, the FSK sync tone is recorded onto one track of the multitrack tape machine. Assuming you have chosen the tempo (or tempos) you will be using, you must first record the FSK tone onto a track of the tape for the entire duration of the music before recording any of the musical parts. To be safe, always record at least 30 seconds of additional sync tone beyond what you think you will need. This way, if you make any last minute changes in the music, if the last note of the song will sustain for a long time, or the song ends with a slow fade, you won't get stuck running out of recorded sync tone before the music's end. A sequencer locked to a sync signal will grind to a halt as soon as it stops receiving the signal.

FSK generators all produce a tone called a *pilot tone*. The pilot tone serves as a reference for setting the tape level and to prepare the sync device for its start. This tone must be recorded for at least a few seconds before hitting Start on the FSK device. The music will start at the moment the FSK tone begins to modulate the pilot tone between two frequencies (representing the clock pulses).

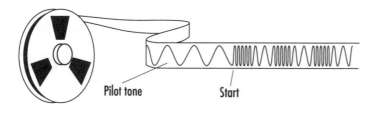

Pilot tone Start

FSK devices can generate clock and MIDI sync while recording the sync tone, or "stripe," on the tape. By sending clock or MIDI to a sequencer or drum machine ready to play back in either MIDI or "Tape Sync" modes, the music can be monitored while the sync stripe is being recorded. It can be helpful to listen to the music while creating the sync stripe in order to know when the song has ended. Keyboards and drum machines connected to the sequencer will play while the FSK signal is being generated, but you should never record any music to tape at the same time as recording the sync tone.

PROCEDURE FOR FSK SYNC

✺ Connect the FSK (or "Tape Sync") output of the device to the audio input of an edge track on the multitrack recorder.

✺ Few FSK generators have level adjustments, so it may be necessary to go through a line mixer in order to get the correct level (this is discussed in the next section). FSK generators send out pilot tones all the time they are not playing, making it simple to set the level.

✺ Start the tape machine recording on the sync track. Wait several seconds and then press *Start* or *Play* on the FSK device.

✺ Do not record any music tracks or clicks simultaneously while recording FSK, or they will end up slightly out of sync with the tracks recorded later.

✺ When the music has ended, let the tape run for at least 30 seconds before stopping the recording.

LEVEL

The level at which an FSK sync tone is recorded onto tape is very important. If the level is too low, the FSK device will not be able to "read it back in" and will not create good sync. This is like not being able to read your own handwriting because you wrote too small. If it is too loud, the signal will "leak" onto the adjacent tracks and ruin the music (FSK tones do not sound especially pleasant) and can also cause the sync device to misread the signal. Manufacturers may recommend different recording levels for their products depending on the sensitivity of the device. However, it is not unusual for there to be no recommendation at all. Generally, levels between -10 and -5 dB will operate most FSK devices reliably with minimal or no noticeable track leakage. When in doubt, perform a test. Record about 20 or 30 seconds of FSK onto the tape at a very low level and play it back into the device to see if it can be read properly. Play back the sync tone a few times. The device should begin to play back at the same time and at the same tempo each time. If there is a problem such as the sequence suddenly stopping and starting again (like a "hiccup" in time), try raising the level very slightly and re-recording it.

OFF AND RUNNING

Once the sync signal has been recorded, connect the audio output of the sync track to the *Audio, Tape* or *FSK In* of the FSK device and the clock or MIDI output of the FSK device to the *Clock, Sync,* or *MIDI In* of the sequencer or drum machine. You are now ready to slave the sequencer or drum machine to the tape machine.

With the sequencer in its "External," "Tape," or "MIDI sync" mode and ready to play back a sequence upon receiving a Start command from the FSK device, simply rewind the tape to a point before the music begins (where the pilot tone begins) and play the tape. The pilot tone gives the tape machine and the FSK converter a chance to stabilize before the music begins. After the pilot tone has started (but before the tone begins to modulate), press *Play* on the sequencer. Now you can begin recording parts on the other tracks of the tape machine. You

will need to start from before the beginning of the music for each track, as the standard FSK process has no way of specifying position within a song (there is a unique form of FSK that can intelligently locate into a song, which will be discussed later).

The track directly adjacent to the one on which the FSK signal is recorded should be left blank, if at all possible. If you need that track, use it for nonpercussive parts like guitar or backing vocals. Drums can leak onto the FSK track and have a bad effect on the accuracy of the signal. Also, be sure that the FSK signal doesn't leak onto the adjacent track so as to disturb the music itself. It's a good idea not to record vocals, drums, or other parts that will be loud in the mix on the adjacent track.

FOR THE RECORD

Sequencers and drum machines synchronized to tape can be used to record as well as play back. For instance, you may have a vocal or special instrumental part on tape to which you want to listen while you play into the sequencer. You may also wish to record a part in the sequencer or drum machine after having recorded other parts or vocals.

Virtually all MIDI sequencers and drum machine have the ability to record while in their "external" or MIDI Sync mode. The technique is identical to standard playback of the sequencer while synchronized to tape.

SUMMARY

Here's a quick, step-by-step description for using FSK to synchronize a sequencer or drum machine to tape:

- ✱ Select the tempo for the music
- ✱ Select an empty edge track on the tape for the FSK signal
- ✱ Connect the FSK Out of the device to the input of the track and the Output of the track back to the FSK In of the device
- ✱ The Clock or MIDI Out of the FSK device should be connected to the Clock or MIDI In of the sequencer or drum machine or other sync device
- ✱ Adjust the recording level to between -10 and -5 (or as specified in the user guide of the sync device)
- ✱ Start recording with the sync device on, but not running (idling)
- ✱ Wait several seconds and press *Start* on the sync device
- ✱ Record the sync track for the duration of the music plus an extra 30 seconds
- ✱ Rewind the tape and send the audio from the FSK track back to the "Audio In" of the FSK device
- ✱ Set the sequencer to its "External," "Tape" or MIDI Sync mode
- ✱ Start the tape and wait for the pilot tone to begin
- ✱ Press *Start* on the sequencer
- ✱ The music will begin when the pilot tone begins to modulate
- ✱ Listen to the sequencer play back in TAPE mode before recording anything to be sure the sync track was properly recorded

SMPTE AND THE RECORDING STUDIO

By far, the most commonly used technique for synchronization in professional recordings today is SMPTE Time Code. SMPTE stands for *Society of Motion Picture and Television Engineers*. This is the technical group that develops the standards used by people in the motion picture and television industries. SMPTE Time Code (generally shortened to just "SMPTE" and pronounced "*simptee*") was originally developed in the late '60s as a synchronizing code for locking visuals and sound together, but has become more and more important in the recording studio as the cost of SMPTE-based equipment has dropped. SMPTE has a number of advantages over click tracks or FSK for synchronizing sequencers and other MIDI devices to tape. However, SMPTE-based devices are, on the average, more expensive than FSK.

SMPTE time code is a digital code that can be recorded onto any tape by means of an audio signal (much like FSK). Unlike FSK or click, the SMPTE time code recorded onto the tape does not represent the tempo of the music. Instead, it measures *absolute time*—much like the clock on the wall—marking the tape in hours, minutes, seconds and fractions of a second. Since the original intent of SMPTE was to synchronize video tape with audio, it breaks time into *frames*, each of which is about a 30th of a second. Since SMPTE does not encode tempo information, it must be used with some kind of translation device to convert the SMPTE code into MIDI messages or clock signals at a given tempo (or tempos) for driving a sequencer or drum machine.

With both click and FSK, every part of the tape looks identical to any synchronizing device. If you were to fast-forward to the middle of a recording with a click or FSK sync track and begin playback, a sync device could not determine the current position of the tape. Clicks and FSK merely mark the next beat or clock tick on the tape (and the next, and the next). They are accurate and reliable, but every part of the tape looks like every other part of the tape to the decoding device. It is much like a street where every building looks the same and has the same address.

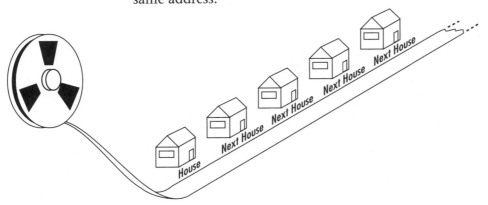

SMPTE time code is completely different, and much more versatile. Unlike click, FSK, or timebases, where every tick of the clock is identical, SMPTE is an intelligent code that puts unique timing information onto every part of the tape. Just like film or video tape, SMPTE breaks time into frames, which are small fractions of a second. There are several different "frame rates" for film and video (much more on that in the next section), but the one used almost exclusively in the recording studio is exactly 30 frames per second. Thus a "frame" (which is simply a single image on the film or tape) of SMPTE time is .0333 of a second or about 33 milliseconds (a millisecond is 1/1000th of a second).

While frames have no direct meaning in audio-only recording, they are a very fine subdivision of time (resolution) and are being borrowed from the video world for purely musical use. It is actually possible to get even finer resolution with SMPTE, as each frame is made up of 80 *bits* (the actual digital 0's and 1's used to describe the current time). If a SMPTE device can work down at the bit level (and many do), their timing accuracy is .0004 of a second, or .4 millisecond. A very small amount of time in the general scheme of things!

A Closer Look

The basic unit of SMPTE time code, just like the video for which it was originally created, is the frame. There are 30 frames in a second of video tape. There are 60 seconds in a minute, 60 minutes in an hour, and 24 hours in a day (I feel a little silly telling you this, but it's important to be complete). Each frame is given a unique time value. Think of the clock on your wall (or your wrist if it is closer to you). The time at noon is exactly 12:00:00 PM. The hour is 12, the minutes and seconds are both 0. The next second is 12:00:01, that is the hour of 12, the minute of 0 and the second of 1. Instead of teaching you how to tell time, perhaps now is the time to say that SMPTE time is almost exactly like a clock, but with finer resolution from the addition of frames.

The hours, minutes and seconds of SMPTE time code move at the same rate as a perfectly accurate clock. (There is one slight exception to this which is discussed in the next section, although it has no effect in multitrack recording.) SMPTE times are notated like standard time with the addition of frame numbers. An example of SMPTE time might be 01:34:18:08, which is "one hour, thirty-four minutes, eighteen seconds and eight frames."

Events such as starting a sequence or triggering a MIDI note can be made to happen at specific times by "time stamping" them to occur on a specific hour, minute, second and frame. For example, a tape may be striped with SMPTE time code starting at 00:59:45:00 (15 seconds before the hour) and going on for several minutes. With a "SMPTE-to-MIDI converter" (also discussed a little later), a sequencer can be set to begin playing or recording at exactly 01:00:00:00. The

SMPTE code is used not only as a reference for when to begin the sequence, but is also used to ensure the accuracy of every beat of the music regardless of any tape speed fluctuations, just like an FSK track.

RECORDING SMPTE TIME CODE TO TAPE

Like clicks or FSK, SMPTE time code is recorded onto tape before the music. Unlike clicks or FSK, there is no need to decide on the music's final tempo (or tempos) before "laying down" the code onto the tape. There are a number of devices that can generate and read SMPTE for use in the studio. Like clicks or FSK, the code is best recorded onto one of the outermost tracks of the tape machine. Although the documentation included with a SMPTE generator will probably give an optimum level at which to record the code, it is worth experimenting to find a sufficiently low level that works for your equipment without errors (during which the synchronizer may be unable to decipher the signal from the tape). As with other sync signals, it is always better to skip the track next to the code because of the possibility of audio leakage between adjacent tracks. Also, it is better to put a nonpercussive or softer part on the track adjacent to the code if you need to use that track.

Track 24

Generally, levels between -5 and 0 dB will work well for SMPTE. These levels are quiet enough to keep from leaking onto other tracks while still giving the SMPTE reader a sufficiently strong signal to operate. If you are using noise reduction, disable it for the track you are using for the time code, if possible. Dbx noise reduction seems to be especially unfavorable for SMPTE code. If it is impossible to disconnect the noise reduction (some home multitrack recorders can't disable noise reduction on individual tracks), then do some tests to find the level that works best with the noise reduction. In most all cases, the SMPTE time code will work fine under any circumstance.

SMPTE time code is transmitted between a track of the tape and the SMPTE generator/reader. If your system uses a patch bay and mixer to route all signals to and from the tape machine, it's better to use a separate patch cord to send the signal directly from the sync track of the tape machine to the SMPTE reader to avoid leakage into the mixer. This is important because SMPTE is a particularly annoying sound if it gets into the audio path of your system (it has been compared unfavorably with the sound of the bombing of Pearl Harbor), and is prone to leakage all over the place. Using a mixer is often unavoidable when recording the signal to tape, since few SMPTE generators have attenuation controls on them. However, since you should not record music while recording the time code, this shouldn't be a problem. Be sure to connect the output of the tape's sync track directly to the SMPTE device and do not go through the mixer while actually locking the sequencer to tape for recording or playing music.

"The metronome has no value...for I myself have never believed that my blood and a mechanical instrument go well together."

Johannes Brahms
Letter to George Henschel (Feb. 1880)

SMPTE AND MIDI

SMPTE-To-MIDI Converters

At the heart of the MIDI-based studio is the sequencer. Some sequencers are stand-alone devices, while others are software-based and available for any of the more popular personal computers. In addition to recording, editing and playing back your music via electronic instruments, most MIDI sequencers also have the capability to synchronize to audio or video tape by means of SMPTE Time Code. This is done through an additional piece of hardware that adds both MIDI and SMPTE capabilities and connections to the computer. SMPTE does not contain any tempo information, but sequencers can be set to record and play at any tempo or tempos. They also can be programmed to begin playing at any SMPTE time. In essence, a sequencer can actually *synchronize each beat of the music with a specific SMPTE time.*

Here's a simple example: A song has a tempo of 60 BPM. At this tempo, the beats are each exactly one second apart. If you set the start time of the sequence to be exactly at the hour (01:00:00:00), the beats would be timed like this:

Tempo = 60 BPM

BEAT	SMPTE TIME (hr:min:sec:frm)
1	01:00:00:00
2	01:00:01:00
3	01:00:02:00
4	01:00:03:00

Beats line up exactly with seconds in this example. The clock starts on the first beat of the music, thus it is at the zero seconds. The SMPTE time code measures the elapsed time of the music. If the tempo is doubled to 120 BPM (two beats per second) here's how the beats would line up with a SMPTE track:

Tempo = 120 BPM

BEAT	SMPTE TIME (hr:min:sec:frm)
1	01:00:00:00
2	01:00:00:15
3	01:00:01:00
4	01:00:01:15

Since there are 30 frames in a second, there is one beat every 15 frames, or twice per second. Now look at a tempo that does not fall so neatly into the time code. This example shows what beats at 100 BPM look like compared to their elapsed SMPTE time code:

Tempo = 100 BPM

BEAT	SMPTE TIME (hr:min:sec:frm)
1	01:00:00:00
2	01:00:00:18
3	01:00:01:06
4	01:00:01:24
5	01:00:02:12
6	01:00:03:00

SEQUENCING WITH SMPTE TIME CODE

A computer MIDI interface functions at the synchronization center of a MIDI-based recording studio. It provides a number of services that may include some or all of the following:

- It generates SMPTE time code that can be recorded onto tape.
- It reads back the time code to enable a sequencer to lock to the tape machine.
- It converts audio SMPTE into MIDI Time Code (MTC). MTC is simple SMPTE time code sent over a MIDI cable, it is still just hours, minutes, seconds and frames, only now it can be read by any compatible MIDI device. The MTC is sent to the computer so the sequence can lock to the incoming code.
- It will indicate to a sequencer when a tape is starting at the beginning or somewhere within the music and, if so, the exact starting point.

There are a number of computer MIDI interfaces currently available. Some offer multiple MIDI Ins and Outs to allow for more than just 16 MIDI channels simultaneously. Most provide both SMPTE In and Out, and vary in the sophistication and quality of their SMPTE reading, generating and regenerating (see page 85). Conveniently, most interfaces can be used with most software sequencers, but you must purchase an interface designed expressly for your brand of computer.

TEMPO MAPS

Tempo is entered into a MIDI sequencer by one of several means: Tempos can be entered numerically right on the keyboard of the computer. MIDI sequencers can have a different tempo on each beat (or less), if desired, for greater musical expression by means of a *tempo map*. Sequencers store the tempo map into a special "tempo track," also called a "conductor track." Tempos can, in some cases, be entered by means of tapping the tempos by hand on a key of the computer or MIDI instrument. Some MIDI interfaces provide a special Audio In port which allows an audio click to be fed into the sequencer, and the tempo analyzed and put into the tempo map. You can also create an expressive tempo map using a MIDI instrument or device with a knob or slider that sends MIDI messages. The knob or slider can be used as a tempo knob by any sequencer that can interpret the MIDI values as tempo changes, and record them into the tempo track. Tempos are expressed in BPM with accuracy as high as 1/1000 of a BPM.

Tempo maps can be revised, edited or modified in a number of ways. Many sequencers have functions for creating *accelerandos* and *ritardandos*. Some also provide sophisticated *tempo calculators* used to assist film and television composers in selecting the exact tempos for making the music fit to picture (see page 53).

The SMPTE-MIDI Connection

One essential aspect of including a SMPTE-to-MIDI converter (or *sync box* as it is often called) into a music system is the need to send both performance information from a main keyboard and synchronization information to the MIDI In of the sequencer at the same time. While a MIDI switching or merging device would take care of the problem, it is not necessary. Virtually all MIDI sync boxes will merge the incoming MIDI performance information from any MIDI instrument with the synchronization messages that it creates. Both are sent over a single MIDI cable to the sequencer, which is able to record the performance data while synchronizing to the clock messages.

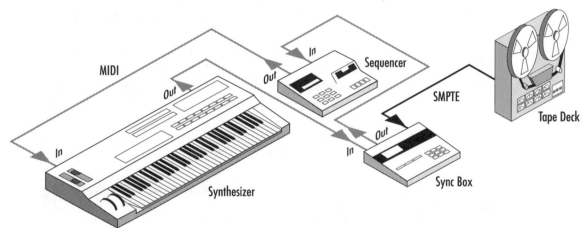

Figure 7.1
A basic MIDI system with a hardware sequencer requires a SMPTE sync box

⊕ The sync box receives MIDI performance information from the master keyboard of the system.

⊕ It also receives SMPTE time code from the tape machine (which could be a VCR as well).

⊕ A tempo and SMPTE start time are programmed into the sync box from its front panel.

⊕ The sync box will generate MIDI clocks at the appropriate rate and will begin at the designated start time. After these parameters are set, the sync box runs entirely automatically, and can be ignored until any changes need to be made.

⊕ The MIDI Out of the sync box goes to the MIDI In of the sequencer, which is set to its MIDI Sync mode.

⊕ Pressing Play or Record on the sequencer will cause it to wait for an incoming MIDI Start or Continue message from the sync box.

⊕ The tape is started, which sends SMPTE time code to the sync box.

⊕ The sync box waits until the designated start time is reached, at which time it sends a MIDI Start message and clock messages at the appropriate tempo.

☿ The sequencer can play the music and/or record a new track while slaved to the tape. Like most SMPTE-to-MIDI converters, many sequencers can be set to play in "Chase" or "MIDI mode" and then be left alone and operated entirely from the tape deck and sync box.

Without needing to reconnect any MIDI cables, the sequencer can be put back into its Internal Sync mode and still receive MIDI information from the keyboard, since this information is being passed through the sync box.

There are some sequencers available (most notably those for the Apple Macintosh computer) which have more than one MIDI input, and can accept multiple MIDI data streams. For these sequencers, it is possible to send sync data to one MIDI port and musical information to the other, thus simplifying the system and taking advantage of some extra speed from the computer.

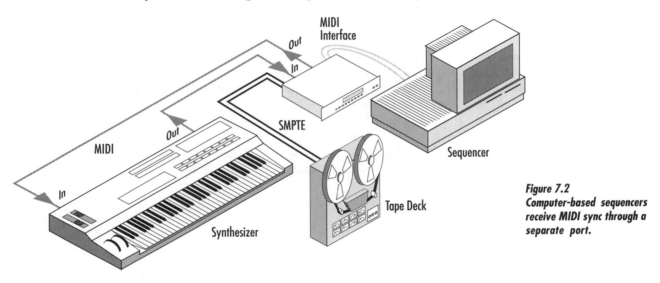

Figure 7.2
Computer-based sequencers receive MIDI sync through a separate port.

TAPE POSITION AND SONG POSITION

Perhaps the greatest power within a SMPTE-MIDI sequencing system is the implementation of Song Position Pointer, covered in the first section of this book. As mentioned above, the sync box waits for the SMPTE start time to come from the tape before triggering the sequencer. But what if the tape is cued up and started at some point after the beginning of the music, thus sending a SMPTE time after the programmed start time to the sync box? The answer is simple and potent: All SMPTE-to-MIDI converters can calculate the amount of time between the specified start time and the current tape position. They then convert this to a MIDI Song Position Pointer message based on the current tempo, which causes the sequencer to locate the point in the sequence matching the tape's position. This message is sent to the sequencer followed by a MIDI Continue message, which starts the sequencer. Any worthwhile sequencer can accept Song Position Pointer messages while in either record or playback mode. This makes it possible to work on sections in the middle or at the end of the music without the need to start at the beginning of the tape.

This configuration makes the sequencer act as an integral part of the physical tape system, allowing everything to be driven from the tape machine's controls.

A Closer Look At SMPTE-Tempo Conversion

If there is no tempo information within a SMPTE time code stripe, how can it be of use in musical synchronization? Answer: As you know, each SMPTE time code message is an indicator of "absolute time," like the clock on the wall. Each frame of a video tape, or every point on an audio tape, has a unique SMPTE "time stamp" that can be read by a SMPTE time code reader. A sync device that reads SMPTE time code and has MIDI sync output capability performs a simple calculation. For example, using the highly popular tempo of 120 BPM, say that you have recorded a SMPTE stripe and are now reading it back. The sync box has two pieces of important information, the tempo and the time the sequence should begin (which for this example will be exactly 01:00:00:00).

When the sync box first receives time code, it reads the code and decides whether the music should have started yet (if the current SMPTE time is past 01:00:00:00) or not (if the current SMPTE time is before 01:00:00:00). If it is before the specified start time, it will wait. When the start time comes, the sync box will send a MIDI Start command and send clock information to any waiting sequencers, drum machines, etc.

At a tempo of 120 BPM, there is one beat every half second. From the SMPTE point of view, that is the time it takes for 15 frames to go by. Put simply, the SMPTE sync box counts incoming frames and, knowing the current tempo, will send clock signals at a rate based on the passing frames and its current tempo map.

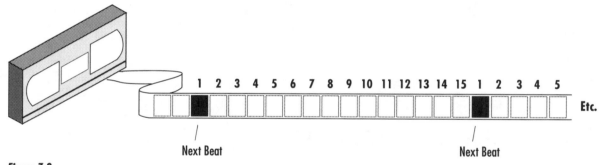

Figure 7.3
A SMPTE synchronizer aligns each beat with a specific part of the tape

As the tempo increases, beats will occur at smaller frame intervals. SMPTE converters are smart and precise. Tempos that do not match exactly to a frame (115 BPM is one beat every 15.652173913043 frames) are none-the-less calculated with near-perfect accuracy using a mathematical function called "interpolation."

Oops, Too Late

A slightly more complex chain of events occurs when a SMPTE-to-MIDI sync box receives as its first frame number a time value that is after the selected start time. Here's what happens:

☻ It must calculate how far past the start point the tape has gone.

☻ It converts that time into the number of beats based on the tempo (or tempos) in its tempo map.

⊛ It sends a MIDI Song Position Pointer that is a few beats beyond the current position (this is to give the sequencer or drum machine receiving the SPP time to locate to the correct position in its sequence memory).

⊛ It waits for the exact point on the tape matching the SPP just sent, and then sends a MIDI Continue message.

⊛ Finally, it continues to send MIDI clocks at the correct tempo.

This is a pretty good "trick," and it all happens in a brief fraction of a second.

"Smart FSK" - An Alternative

SMPTE synchronization devices add a great deal of power and ease to a MIDI-based studio, but at a cost (literally). FSK devices, while much less expensive, are quite limited in comparison. There is an interesting intermediate system that combines reasonable cost with the SMPTE time code's auto-location capability. The system is called "smart FSK," "SPP FSK" or "Poor Person's SMPTE." It is found on synchronizers from J.L. Cooper Electronics and Passport Designs.

These devices, which are compatible with each other, generate a unique time code which embeds MIDI Song Position Pointer messages along with the clock-based FSK signal. While tempo must be decided before recording, as with standard FSK, the system does permit you to start the tape from any point within the music and have the sequencer locate to the appropriate location within the sequence.

Working With Recordings Lacking Clicks Or Timebases

A Scenario:

You are asked to do "sweetening" (record additional tracks) on a recording that was done without time code or clicks. You need to work with a sequencer or a drum machine, but there seems to be no way to lock everything together. What are you to do?

A Possible Solution:

An accurate sync track can be created either with a SMPTE synchronizer into which the tempos can be tapped by hand, or with a click converter. Both techniques involve manually tapping the tempo while listening to the music. Tapping into a SMPTE converter records each beat's unique tempo.

A SMPTE stripe is recorded first onto an empty track of the tape and then *played back into the converter while tapping along with the music*. If the beats tapped into the converter are accurate, you now have a tempo map that can be used to drive sequencers or drum machines in time with the music.

Similarly, a click can be recorded onto any empty track of the tape. This can be done by tapping a button on a drum machine or by actually playing a percussion instrument such as claves into a microphone. The clicks can then be fed into a click converter or into a MIDI converter with an audio click input for learning tempos.

In either case, the trickiest part may be entering the first click of the music into the sync box if there is no count-in on the tape. This can only be done by simple trial and error (and error and error). Watch the tape counter or listen for some specific sound on the tape for a cue.

A more elaborate scheme to get clicks from the beginning is to record clicks from a beat as close to the beginning of the music as possible and continue to the end. To fill in the missing clicks at the beginning of the music, and possibly even add a count-in, flip the tape over and listen to the new click track and record new clicks onto another empty track when the first click track runs out. Finally, to consolidate the clicks onto one track, copy the clicks from the count-in track onto the first click track and erase the count-in track.

Another Possible Solution:

The above method for creating a click map is effectual, but can be awkward. Each beat must be entered manually by tapping. If an error is made, you will need to start again from the beginning. Some sync boxes do not have a manual tap tempo feature. One alternative is to record the clicks onto a track of the master tape first, then play the clicks into the sync box. Individual "problem clicks" can be replaced by punching in and out of the tape. This is not easy or even possible with most SMPTE sync boxes.

Yet Another Possible Solution:

For SMPTE devices that have an audio click input feature, there is yet another way to build a tempo map from a music source with no click track. The music must have a rhythm, percussion or mixed track that keeps a constant beat throughout the music. The audio from that track is put through a noise gate or "audio expander circuit" that has a variable threshold. This device will only allow the loudest parts of the track to pass through it. By carefully adjusting the threshold level (if the device has "attack" or "decay" controls these should both be set to their fastest settings), it is possible, depending on the music, to get only a pulsing of sound in the tempo of the music. These pulses can be fed to the sync box in place of clicks for a perfectly accurate click track. Some of these audio devices allow for a "time window" that ignores audio peaks for a specified time after the most recent one. This makes it possible to ignore some drum fills or other rapid sounds in an otherwise simple track.

As with manual tapping, the tape with the music should first be striped with SMPTE time code, and the code played into the sync box simultaneously with the audio pulses.

LOCKING TAPE MACHINES TOGETHER

There seems to be an unwritten law of music recording that says there will always be enough musical parts to use up all the available tracks on a tape, plus one more part. Multitrack recording began in the 1950s (credited to guitar legend Les Paul) and has grown in popularity and capacity ever since. After many years of only mono recordings on 1/4" tape, the first 3-track recorders were introduced using 1/2" tape. These were used as multitrack masters that were mixed down to mono for pressing onto records. Soon after came the first 2-track machines (again on 1/4" tape), followed by the first 4-track machines (on 1/2" tape). When that became a limitation, the 8-track was developed, which was surpassed by 16-tracks and then 24-tracks. All of these formats are still around and popular in some areas of recording. In addition to these, there are some home 12-track tape decks, and also state-of-the-art (at least for now) 32 and 48-track digital machines. These advances in technology have come about due to the demands of modern recording and continuing sophistication in new music. Before getting into a "more is better" campaign, it's always good to remember that the Beatles' masterful and complex "Sgt. Pepper's Lonely Hearts Club Band" was done entirely on a 4-track machine, the best available at the time.

Situations will arise when there simply aren't enough tracks on a multitrack to get what is needed on tape. One option is to go with a bigger tape format, but this isn't always possible. The other option is to use two tape recorders and "lock them up" so they run in perfect sync with each other—as though they were one big recorder. This is accomplished with the use of a special device called a *synchronizer* and two or more compatible tape machines.

What makes a tape machine capable of being slaved is the presence of an "external control" connector. Higher quality 2-track and multitrack recorders from most companies will usually have the ability to be locked together, or *resolved* with another deck. Some home recording equipment can also do this, though you will find this ability less often than with professional equipment.

A tape recorder that is externally controllable has a special purpose connector to link it with a synchronizer. Currently, there is no standard format for this connector, and one must often be custom-made for linking a specific tape machine with any specific synchronizer. Directions for the construction of a cable for this purpose are usually included in the manual for the tape machine and often with the synchronizer. Stores that sell this sort of equipment will usually carry the cables as well, but expect to pay handsomely for them.

Identical SMPTE time code stripes must be recorded onto a track of each tape. Thus, synchronizing a pair of 24-track machines will yield only 46 usable tracks (44 if you wish to avoid the tracks adjacent to the time code). The role of the synchronizer is to compare the SMPTE tracks on the tapes on each machine and control the recorders' motors in the event that the two tapes drift apart from each other.

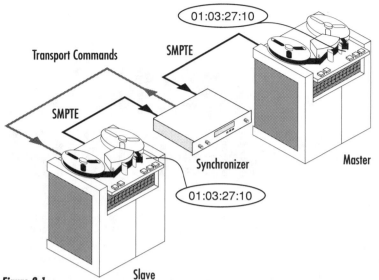

01:03:27:10

Transport Commands

SMPTE

SMPTE

Synchronizer

Master

01:03:27:10

Slave

Figure 8.1
Two multitrack recorders
connected with a
synchronizer.

⊛ SMPTE time code from a track on each machine is fed (by standard audio cables) to "Master Time Code" (MTC) and "Slave Time Code" (STC) inputs on the synchronizer.

⊛ Controller cables are connected from the synchronizer to the slave machine, or to both master and slave depending on the sophistication of the recorders.

⊛ When the tape on the master machine is played, SMPTE time code from the sync track is sent to the synchronizer.

⊛ The synchronizer responds by starting the motor on the slave unit.

⊛ The slave recorder starts sending SMPTE time code from its tape to the synchronizer.

⊛ The synchronizer now compares the incoming SMPTE times and checks for any *offset*, which is the difference between the incoming numbers. (Note that this use of the word "offset" is different than when referring to start times in SMPTE-MIDI sequencing systems.) For example, if the synchronizer detects that the slave unit is behind the master, it will command it to speed up its motor to catch up with the tape on the master.

⊛ When the SMPTE numbers coming from both machines match exactly, the synchronizer returns the slave to normal speed.

⊛ If any further drift is detected, the motor on the slave is once again varied slightly to compensate.

The comparison of tape locations and adjustments to the slave recorder's speed are done so rapidly that the machines never have the opportunity to drift apart by more than a tiny fraction of a second before they are corrected. Tape speed fluctuations are so small that they are unnoticeable. From the time the master tape is started, there are usually a few seconds of very noticeable adjustments in the slave deck's speed before the two machines are perfectly locked together. The master tape recorder is operated normally, either from its own transport controls or from its *autolocator* (a sophisticated remote controller that can operate every function of the machine and move the tape to specific locations). The synchronizer and slave machine operate completely in the background, providing the illusion of a single multitrack system.

ON THE REWIND

When the master tape recorder is playing or recording, its SMPTE code track is running the synchronizer and, in turn, the slave unit. But how does the slave know when and how far to rewind or fast-forward and stop when the master is being shuttled? During rewind or fast-forward, the tape is not playing and thus no time code will get to the synchronizer.

Tape recorders use several motors in their operation. One controls the *capstan*, the small metal roller that guides the tape across the heads and maintains an accurate speed. There are also motors that fast-forward and rewind the tape. These motors (or one of the *flywheels* along the tape path) are often used to send

an electrical pulse to the electronics of the recorder that control the tape counter display. These pulses, called *tach pulses*, are sent by many tape machines to the synchronizer through the connector cable. The synchronizer can detect the direction and speed of the tape reels and then make an estimate of the current location of the tape. It will command the slave device to fast-forward or rewind at the same rate and to stop at the appropriate time. When the tape is played again, the synchronizer will check and compare the locations of the two tapes once again and make any necessary adjustments in the slave unit. A good synchronizer has the ability to "learn" about a tape machine by examining the tach pulses and comparing its estimate of tape position with the actual tape destination, and then compensate for its own errors. The more the system is used, the more accurate it becomes.

Not all tape machines will send tach pulses to the synchronizer. In these cases, some synchronizers can defeat the "lifters," which are the devices that pull the tape away from the tape heads during fast-forward or rewind and send a "mute" command to the recorder so as not to blast the room with ear-splitting, high-pitched screams. This provides the synchronizer with audio code even during high speed tape winding, and it can continue to operate the slave normally.

When neither tach pulses nor high-speed code reading is available, the system must work in a "code only" format, unable to track the fast-forwarding or rewinding of the master unit. In this case, the slave needs to be rewound manually near to the correct starting point, after which the synchronizer will adjust it accurately. Otherwise, the slave machine will only rewind after the master has started playing. The process is less "invisible" since you need to operate both tape machines, but offers equally accurate results.

Do You Copy Me?

There is a completely different reason for wanting to lock tape machines together: For transferring audio tracks from one tape to another. One primary reason for this is to take well-made tracks done at home on an 8-, 12- or 16-track recorder and "bounce" them onto 24- or 32-track tape to add additional tracks.

Assuming that you used SMPTE time code while working at home, you will need to transfer the code from one tape to the other, as well as transfer the audio tracks so the sequencer will continue to match the recorded parts. There are two ways to do this, depending on the equipment available:

- Record SMPTE time code onto one track of the new tape. With a synchronizer as described above, lock both tape machines while transferring the audio tracks. Keeping the machines locked together prevents any speed fluctuations in the smaller machine from affecting the tracks once they are transferred.

- Copy the time code from the smaller machine at the same time as the other audio tracks. It is very important that you use a time code regenerator or reshaper in this process. Most tape machine synchronizers have this capability built-in. This technique is explained fully in Chapter 17.

Using SMPTE Offsets

It is possible to synchronize tapes that each have their own unique SMPTE location or start time by the using the *offset* function of a synchronizer. A synchronizer capable of offsets allows you to input the *difference* between the start times of the two time codes.

Offsets can be used in a number of situations. One example is vocals that are recorded (or copied) onto a separate, synchronized tape machine with time code. By calculating an offset, an excellent performance of a first chorus can be offset and dubbed back onto the master tape machine in the second chorus. Vocals or other recorded parts on a slave tape machine that feel out of time with the rest of the track can be "fine tuned" until they fit perfectly. Sequences can be moved forward or backward in time to match up with tracks recorded onto the tape.

Depending on the synchronizer, offsets can be specified as positive (the master's time is later than the slave's) or negative (the slave's time is later than the master's). The offset is calculated as:

> **The larger of the two times**
> - **The smaller of the two times**
> = **The offset**

Remember that in subtracting one SMPTE time from another that there are 30 frames in a second and 60 seconds in a minute. Here is an example of an offset calculation:

> **01:03:12:05 (master time code)**
> - **01:00:30:20 (slave time code)**
> = **00:02:41:15 (resulting offset)**

While it is rather simple to calculate the offset between two tapes and enter them into a synchronizer, many synchronizers can perform a *capture offset* function. Both the master and slave tape machines are located to the desired locations on their tapes and stopped (or "parked," as it is called). The most recent SMPTE value is remembered by the synchronizer. When the "Capture" button is pressed, the synchronizer automatically programs the difference between the two decks SMPTE time into the offset. The machines are synchronized, and the synchronizer maintains the offset. Some synchronizers can capture the offset even as the tape machines are playing.

If an offset is needed that is an exact number of measures or beats apart (such as synchronizing a vocal from the first chorus of a song to the third chorus) a sequencer with a real-time display (hours, minutes, seconds and either a fraction of a second or frame) can be used to help with the calculation. Using the sequencer's locator, set the number of bars for the offset desired along with the tempo of the music, and the real-time indicator will display the offset time to program into the synchronizer.

Once an offset is achieved, there may still be a need to perform more fine tuning in order to get the right "feel." Synchronizers assist in this by providing a function called *trim* or *slew*. This function slides the relative positions of the master and slave forward or backward to one another by small fractions of a frame (either 100ths, or "bits," which are 80ths), thus allowing you to find the perfect offset while listening to the two tape machines play back.

There are uses for offsets in work with video. For example, suppose you wanted to synchronize a specific scene on a video with a pre-existing recording on multitrack track. Each has SMPTE time code recorded on a track, but there is no correlation between the two times. The video and audio machines can be synchronized with an offset that lets the music begin playing at any desired point in a scene.

Digital Audio for The MIDI Studio

The cost of digital recording dropped considerably with the introduction of "consumer" multitrack and 2-track DAT (Digital Audio Tape) recorders. These machines add amazing new quality to the budget project studio, and have found their way into the professional audio environment as well. Along with this capability are some concerns:

While DAT recorders offer superior sound quality for stereo recording, only a few very high-end machines can be used in a synchronized environment. Those DAT recorders have special SMPTE synchronization functions built right into them, and do not use an external synchronizer. These "professional" DAT machines also have the capability of adding SMPTE onto a special third track used only for time code, still allowing for stereo sound. Standard DAT machines have no such capabilities.

Also available are small-scale digital multitrack recorders for the home or professional studio. These relatively affordable recorders offer superior digital sound quality in formats of 8 tracks or more. Some models must record SMPTE onto one of the tracks, while the better systems provide an extra time code track. Digital multitracks either have synchronization capabilities built in, or have add–on synchronizers available. Because of the accuracy needed to record sound digitally, the synchronizers for these machines are somewhat different, and general use studio synchronizers do not always work. One of the added capabilities with small digital multitracks is the ease by which multiple units can be "ganged" together to provide more tracks without a lot of additional synchronization equipment.

Figure 8.2
The Tascam DA-88

Multitrack "Sync-Holes"

Problem solving is usually a process of elimination. When things get as complex as they do in a serious (or not so serious) synchronized recording situation, "interesting things" are bound to come up. By tracing a problem and testing every element or device that could be involved, you should be able to find and stamp out most fires before they spread. Here are a few maladies with possible ointments for their cure.

THE PROBLEM: The sequencer does not start when it should while locked to time code.

THE FIX: The heartbreak of sequencer failure can come from a number of sources:

- Check that the cables are of good stock and are firmly seated where they belong. A dirty connection on the audio cable carrying the time code could easily gum up the works.

- If there is any suspicion that the sync code is not getting to the sync box, connect the cable carrying the sync signal to an audio monitor (i.e. the mixer) to verify that something is getting through. Be sure the volume is low!!

- Double check that no cables have been crossed to the wrong destination.

- Make sure that all the MIDI cables are securely connected as well.

- With any sync code, the level needs to be just right — not too hot and not too cold. If the direct audio output of the audio tape recorder or VCR is not working, feed the signal through a channel of the mixer to boost or attenuate it (if the signal was well-recorded, this should never happen, but everyone has bad days).

- If you are using SMPTE, be sure that you have the correct start time (offset) programmed into the sync box.

- The sync device needs to be set to play back its tempo map and be in its "External" or "Tape" mode in order to read the time code and start sending MIDI clock signals.

- The sequencer must be in its MIDI sync mode and must also be in Play or Record in order to start with the time code.

- In moments of desperation you may want to try a different set of cables. (Sometimes it works).

- Be sure that all the synthesizers are set properly by playing the sequencer in its internal sync mode. If the synths do indeed play back, then the MIDI cable going from the sequencer to the synthesizers can be used to test the connection from the sync device to the sequencer.

- When all else fails, turn everything off and on again to reset the equipment.

THE PROBLEM: A sequence starts at the right time, but drifts after it starts.

THE FIX: Don't you hate it when that happens? There are a couple of culprits that can cause this nasty annoyance.

- The first thing to check is the tempo programmed into the sync device (if it is a SMPTE-based device). Be sure that *every* beat is at the correct tempo and there

are enough measures to cover the entire piece.

☻ If everything seems to check out with the sync device, then check to be sure that the sequencer is in MIDI sync mode.

☻ Be sure that the sync device is getting a good signal level from the tape or VCR by sending it through a mixer or line amplifier and adjusting the gain.

☻ Check that there is sufficient preroll time before the beginning of the music (at least five to ten seconds).

☻ See if there are any drop-outs (momentary drops in the signal) on the sync code track of the tape. If there are serious drop-outs, you could be in serious trouble. If you have used SMPTE time code and already have instruments on the tape that you wish to keep, you can try to re-record the sync code and then manually find a new offset time. You can also "jam sync" the code onto another track of the tape, a technique described in the next section.

☻ If you used FSK or clicks and have "keeper" audio material on the tape, you are in bigger trouble. You secretly did want to redo that guitar part, didn't you?

☻ If you change to a different model of synchronizer, there is a strong chance of drift due to minute mathematical errors in the devices called "round-off error." Always use the same synchronizer for all phases of a project.

THE PROBLEM: Music has been sequenced and recorded without count-in clicks when there was no plan to use live players. That plan has now changed, and a musician must be able to play at the very beginning of a song

THE FIX:

Solution 1:

☻ If the tape has SMPTE time code but no clicks, use the click output from the sync box to record a click track onto one track of the tape machine. If a count-in cannot be programmed into the sync box, then calculate the length of one measure (locate to measure 2 of the sequence and look at the real-time display of the sequencer or the sync box) and subtract that amount of time from the the SMPTE start time of the song in the sync box. You can now use the sync device to record count-in clicks onto the tape (or live into the musicians' head-phones). When the count-in has been recorded, set the sync box back to the normal start time for the music.

Solution 2:

☻ With clicks on the tape starting on the first beat of the music, start by taking the tape and turn it over on the tape machine.

☻ Find the track with the clicks. If it was on track 1 of an 8-track machine, it will now be on track 8. If it was on track 2, it will now be on track 7, etc.

☻ Take the audio output of the click track and feed it to a digital delay set to high "feedback" or "regeneration."

☻ Using the delay chart in Appendix B, find the delay time that will produce quarter notes (or whatever the clicks are playing) for the tempo of the music.

☻ Play the click track through the delay, and at the moment the last click plays (the first click of the song), record the output of the delay onto a track that is empty at the beginning of the music.

☻ Count out the number of count-in clicks you desire and then stop the tape or cut the output of the delay.

INTRODUCTION TO FILM AND VIDEO

"Film is truth 24 times a second."

The above quote, from the French film director Jean-Luc Godard, refers to the technical side of how the illusion of movement is perceived on film, (or video) when in fact there is none. How do movies work, and how does that affect the way in which music and sound effects are added to the images?

A film (and video can be included in this since they both work on about the same principle) is a series of still images photographed with a camera capable of taking a number of snapshots, called "frames," every second. The speed at which the pictures are taken, called the "frame rate," is fairly high. Different frame rates are used for film and video in the U.S., and in other parts of the world as well. Film uses a frame rate of 24 frames per second (hence the quote above). The frame rate for video is either 30 or 25 frames per second depending on where in the world you happen to be watching TV.

The eye does not perceive the images shown on the screen as a series of rapidly changing still pictures, but instead blends them together with a neurological function called *persistence of vision*. When you are presented with an image, that image stays in your eyes for a fraction of a second after the image has been removed from the screen. You may have noticed that when someone takes a flash picture of you, it seems as if the flash bulb dims slowly. In fact, the light cuts off completely and immediately as soon as it has flashed (a tiny fraction of a second). The perception that the bulb dims slowly is due to the phenomenon of persistence of vision. It is this same phenomenon that allows you to see motion from a rapid series of still images presented to your eyes in a film or video.

Suppose that you are presented with a still image for a fraction of a second:

Figure 9.1
The sense of motion comes from slight differences between frames in a film or video

The image is then removed from the screen. For a very brief moment, the screen is left blank, but you cannot see that. While the first image is still in your eye (due to persistence of vision) the next, slightly different image is presented:

This is repeated over and over again. The result is the sensation that the picture is moving, but it is really just your brain attempting to make sense of the rapid series of still images. During the early years of film, experiments were performed to determine the best frame rate to use. If the frame rate is too slow, the picture begins to flicker and the movement within the images seems artificial. If the frame rate is too fast, film making becomes too expensive due to the amount of film that is used up every second.

The 24 frame-per-second frame rate used in film is a compromise to achieve the smoothest possible motion using a reasonable amount of film. The 30 frame-per-second rate used in video came about because video recording and playback devices can use standard alternating current (AC) house current to control their speed accurately. This is why video in the U.S. is 30 frames per second, since the frequency of standard AC house current is 60 cycles per second. In most parts of Europe and the Far East, the frame rate is 25 per second, since the frequency of AC in those places is 50 cycles per second.

FRAMES AND SOUND

While the continuous movement you see in motion pictures is actually a series of flashing snapshots, the same is not true of the sound you hear with the picture. There is no such thing as "persistence of hearing" that allows us to mentally blend a series of short sound bursts into a continuous sound. So, how does motion picture sound work? Here's a basic look at how films make sound.

The technology used to combine sounds and motion pictures has changed very little since the days of the first "talkies" in 1927 with films such as *Don Juan* or Warner Bros.' *The Jazz Singer*.

Al Jolson in The "Jazz Singer"

John Barrymore in "Don Juan"

As shown in the illustration below, there are a number of elements to a section of 35mm film. The small holes at the edges, called *sprocket holes,* are used by special gears (sprockets) in the projector to move the film into place. Between the sprocket holes are the actual frames that contain the images to be projected. There are four sprocket holes per frame.

To the left of the visual frame is the area of the film used for sound. Sixteen and 35 millimeter film (the latter being the most widely shown format in theaters around the world) both use an optical system for recording and reproducing sound.

Film sound is the optical equivalent of ordinary vinyl records. While a record has a groove cut into vinyl with wiggles that move a stylus to represent the sound, a film soundtrack has a stripe of wiggles that breaks a beam of light to represent the sound. A light-sensitive cell on the opposite side of the film from a bright lamp converts the flickering light back into sound just as the record needle converts the wiggles in the groove back into sound. There are actually two stripes on the side of the film to provide the left and right tracks for stereo. Using special electronics, it is possible to get up to four tracks (left, center, right and "surround") onto the film soundtrack, though they will not be as separate and discrete as multitrack tape.

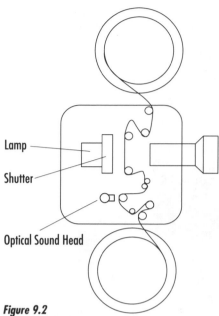

Lamp

Shutter

Optical Sound Head

Figure 9.2
A separate lamp and sensor are used to reproduce sound in 35mm film.

The larger 70 millimeter film format found in large movie theaters uses magnetic stripes instead of the optical process. As a result, the sound quality of 70mm film prints is significantly better than that of the smaller formats. Things change slowly in the world of film, and optical sound on 35mm prints is not likely to change overnight.

Figure 9.3
A frame of 35mm movie film

From a synchronization point of view, there is no difference at all between working in 16, 35 or 70 millimeter formats. There are some differences in the mixdown procedures for the different formats (monaural, stereo, four-track, six-track, Dolby, Ultra-Stereo and so on). This should be discussed at length amongst the composer, sound engineers, transfer house and production company to ensure the best possible final product.

Figure 9.4
The optical soundtrack found along the edge of the film.

Given the magnetic nature of video tape, it is no problem to place both the visual and audio portions of a video onto the same tape. While the visual elements use up the majority of the tape's width, an area along the tape's edge is reserved for the sound. Standard magnetic record and playback heads lie in the path of the tape to handle the soundtracks which range in number from one to four, depending on the video tape format.

THE HIT LIST

The purpose of music in movies is to heighten the dramatic content of the work. Music functions as a psychological amplifier for whatever emotion is being depicted on the screen. Sad becomes very sad, happy becomes very happy, tense becomes very tense. Music adds flow and cadence to any scene in which it is used, no matter how quietly it is played (and more often than not, it is played *very* quietly). Try watching a movie on television with the sound turned off to see how much depth is added by sound and music.

Music for films must adhere to the picture perfectly and change at exactly the right moments. When a visual event occurs on screen, the music can bring attention to it by having a musical event occur at exactly the same moment. Such a musical event is called a *hit*. There is both an art and science to writing music that catches the hits on the screen perfectly while remaining truly musical. It involves mathematical calculations as well as strong intuition and creativity. While there are now computer programs to assist in analyzing the timing of a scene, perform these calculations and suggest tempos, it is still important to understand the underlying concepts behind film composition.

Once the music has been composed, there is still room for errors and problems. Movies are a collaborative process. The composer will most likely be working with a number of other people in order to integrate the music with the rest of the sound and picture. The composer must understand how movies are made, and the other people involved in the production must understand how a composer goes about creating and recording the music. There are technical conventions that must be used to avoid complications. If any technical conventions are ignored, it should be done with a clear awareness on everyone's part.

DOING IT

In this section of the book, you will get a close look at the technology behind film and video soundtracks. The actual techniques of composing music for film and video are not discussed here, being outside the scope of this book. However, the conventions, systems, technology and terminology of composing for pictures (or "scoring," as it is called) are examined in detail. Recently, technology has had an enormous impact on film and video sound production with the help of MIDI, SMPTE and the personal computer. You will see how all these elements are used in the process of creating a product that meets the difficult demands of show biz.

"You ain't heard nothin' yet."

Al Jolson
The Jazz Singer (1927)

FLOW CHART OF FILM/VIDEO POST-PRODUCTION

How is a film or video production put together, and how and when does music enter into the process? While there are always variations and exceptions, there is a flow to film and video production that dictates some aspects of how a composer or sound designer will work. Here is the typical flow of a production as it applies to a composer. Some of these elements are covered in more detail later in this section.

Script is Written

Script is approved for "preproduction" (research into possible production).

No — **Production is approved** — Yes

Producer and director are hired

Possible composers are contacted to read script and submit demos, usually "on spec" (i.e. for free).

Composer is selected and negotiates contract before being hired.

The Film is a Musical — Yes / No

Possible composers are contacted to read script and submit demos, usually "on spec."

Composer is selected and negotiates contract before being hired

Filming/taping begins

On-screen music is played on the set with special synchronizing tape deck.

Filming/taping ends

Editing visuals begins

In addition to visual editing, dialogue that was recorded on a set or on location may be replaced by the actors in a sound studio with a process called "ADR" (Automated Dialogue Replacement), or "looping." The sound effects editor will also begin assembling all the sound effects for the soundtrack.

The music editor may be asked to compile a "temp track" of appropriate music to assist the picture editor in cutting. This will be replaced later by the real score. The composer may be asked for fragments from previous scores to help complete the temp track.

Composer may begin sketching themes for real soundtrack. May need approval from director, producer and/or music editor.

Editing visuals ends

Composer views film to determine placement of music (called "spotting").

List of timings (called a "Cue Sheet") is compiled to assist composer in writing.

Composer begins writing music

(By this time, a production is usually behind schedule and over budget. Therefore, in most cases a composer is given a strict deadline to complete the score and may need to look at ways to reduce the music costs.)

Composer may be asked to submit a demo of each cue before going on to record. (This is especially true for composers working with synthesizers and sequencers.)

While writing the music, the composer keeps a "Bible" of all compositions, with production numbers, titles, starting time, duration and tempo.

Composition is completed

(By this time, most or all of the sound effects and dialogue replacements have taken place.)

Composer (and possibly music editor) makes arrangements to begin recording. This includes hiring musicians, selecting a recording studio, purchasing needed materials (such as tape), and renting any necessary equipment (such as a professional model VCR, SMPTE synchronizing equipment, etc.)

Music is recorded. (If the facility is available, all recording is done while watching the picture to ensure accurate synchronization between music and visuals.)

Music is mixed to the technical requirements of the production (stereo/mono) 2-track, 4-track, etc.

Music mixes are transferred to film stock or video tape for editing.

The music editor places the music mixes in sync with the visuals.

Final sound mix, also called the "Dub," blends the music with final dialogue and sound effects.

(This process is done one film reel at a time, while watching the picture in a special recording studio called a "dubbing stage." Special sound engineers are used for the final dub.)

If the final product is considered acceptable by the producers, it is duplicated, distributed, promoted, and presented.

POPCORN!

TEMPO

Beats Per Minute (BPM) vs. Frames Per Beat (FPB)

In the early days of film, before the creation of electronic metronomes, tempos for the musical cues were generated by recording a single click onto a piece of 35mm sprocketed film called *mag* (the film is coated with the same magnetic material used in audio tape), which was formed into a loop and fed through a playback device with sprockets. Different tempos were created simply by adjusting the number of frames in the loop. The shorter the loop, the faster the tempo. Since the click loop had sprocket holes, it could be mechanically synchronized with the film projector. A special machine locked to the motor of the projector ran the loop and played back the click sound for the conductor and orchestra. The music was conducted while listening to the mechanically synchronized click and watching the picture. Instead of being calibrated in beats per minute (BPM), which is the most common way of specifying tempos for musical scores and standard metronomes, the tempos created by this process were expressed as "frames per beat," based on the number of film frames in the click loop.

There is a basic problem in using BPM in film and video scoring that requires musical events to exactly match the visuals. Film, for example, runs at 24 frames per second, which means each frame lasts .041666666 second. The major goal in film and TV composition is to have musical events synchronize with visual events. Therefore, it is desirable for particular beats to land directly on specific frames, regardless of tempo. If tempos are expressed in BPM, there are only a few tempos that correspond with the film frames exactly. However, by using a metronome that is calibrated in frames per beat (FPB), all tempos will correspond to the frame rate in some way. This is exactly how most film composition is done, in FPB.

Here's a comparison of BPM with FPB: A metronome set to 60 BPM will click once every second, since it is set to click 60 times a minute. The same tempo for film music would be 24 FPB. Since there are 24 frames per second in film, then a click heard every 24th frame would sound once per second, which is the same as 60 beats per minute. To the left are some examples to help you visualize this concept.

If the only tempos allowed in film music were those for which every beat lined up with a frame of the picture, there would be very few tempos available. Digital metronomes, which are used for film click tracks, are calibrated in 1/8th frame increments. Although not every tempo will have each beat line up with a frame of the film, all tempos will have many beats that do line up with frames. By relating the

> 24 frames per beat = 1 beat per second
> 1 beat per second = 60 beats per minute
> 60 BPM = 24 FPB
>
> or
>
> 12 frames per beat = 2 beats per second
> 2 beats per second = 120 beats per minute
> 120 BPM = 12 FPB
>
> or
>
> 18 frames per beat = 1.5 beats per second
> 1.5 beats per second = 90 beats per minute
> 90 BPM = 18 FPB

calibration of tempo in the medium with which it is being used, selected beats in the music can more accurately hit specific events in the picture. Most synchronization devices designed for film or video work that are capable of generating clicks or other sync signals will allow tempos to be expressed either as BPM or FPB. The ability to work in FPB is not essential to composing for picture, but can make finding appropriate tempos simpler. Faster tempos, calibrated in either BPM or FPB will tend to have beats fall very close to important frames in the picture.

Watch This: There is a clever trick for calculating a tempo in FPB with a stopwatch:

- ☿ Think of the tempo in your head or tap it out with your foot or hand.
- ☿ Start counting beats while simultaneously starting the stopwatch.
- ☿ Stop the watch exactly on the 25th beat for 24 frame tempo, or the 31st beat for 30 frame tempo.
- ☿ The time on the watch expresses the tempo in *frames per beat*.

"Movie music is noise. It's even more painful than my sciatica."

Sir Thomas Beecham
Time (Feb. 24, 1958)

"Man, I can't listen that fast."

Unnamed jazz musician, on hearing Parker and Gillespie's 'Shaw Nuff'
Palmer, "All You Need Is Love" (1976)

FILM SYNCHRONIZATION

While the technologies used in creating musical scores for film and video are very similar, there are some peculiarities and conven–tions unique to film. Video, unless it is first shot on film and then transferred to video tape, exists as a single unit. Film on the other hand, because of its more physical nature, cannot fit onto a single reel at one time, and so is broken down into a number of smaller reels that are more manage-able. Films are shown in movie theaters on reels that last approximately 20 minutes. However, during post production, these reels are broken down even further into what are called *production reels*, which each last about 10 minutes. This makes them easier to handle and manage while editing.

Until the final theatrical film copies are made, the visuals and sound do not exist together. Film is silent. For each production reel of picture, there are a number of additional reels for the sound. These are made up of the 35mm mag material mentioned earlier. Because of its sprocket holes, mag can be run through the same editing equipment as ordinary film. By including record and playback heads in the editing system, the sound on the mag can be edited in the same way as the film, and because of its sprockets it can be mechanically synchronized to the picture reel with gears. When the film is completed, the sound is mixed and transferred onto the film's optical soundtrack for projection at movie theaters everywhere.

A CLICK IN TIME

A composer of music for film or television must remain sensitive to every visual aspect of the picture. Changes in scenery, spoken words, people or aliens moving about, or even a subtle facial gesture (human or alien) may evoke a musical response in the score. Composers have a number of ways to produce a film score that will be perfectly synchronized to the picture. For many years, a special "click track book" has been widely available to assist a composer in select-ing tempos that will cause a specific beat of the music to occur precisely on an important frame of the film, called a "hit."

THE TEMPO IS 9.000 FRAMES PER BEAT METRONOME = 160										
BEATS	0	1	2	3	4	5	6	7	8	9
0	.00	.00	.38	.75	1.13	1.50	1.88	2.25	2.63	3.00
10	3.38	3.75	4.13	4.50	4.88	5.25	5.63	6.00	6.38	6.75
20	7.13	7.50	7.88	8.25	8.63	9.00	9.38	9.75	10.13	10.50
30	10.88	11.25	11.63	12.00	12.38	12.75	13.13	13.50	13.88	14.25
40	14.63	15.00	15.38	15.75	16.13	16.50	16.88	17.25	17.63	18.00

Each page in the book represents a different tempo in increments of 1/8th of a frame per beat. The example shows the exact time, in seconds, tenths, and hundredths, on which each beat of that tempo will fall. The composer, often with the help of a music editor (described further on), gets the timings of each event (*hit*) that is musically significant. Starting with a rough approximation of the desired tempo, a composer will look for a tempo in the book that has beats falling on or near the desired times. If the tempo doesn't work, chances are that moving to a slightly faster or slower tempo will.

The ear is very sensitive. Sonic events that occur more than two or three frames away from the hit will be noticed as being wrong by the audience. This translates to roughly 2/10ths of a second. One/tenth is a preferable maximum deviation between visual action and the corresponding beat. Errors that are early (the musical event happens before the frame for which it was intended) are significantly more noticeable than errors that are slightly late.

After the scenes to be scored have been selected (described in the next section), the composer is faced with blank score paper, an empty sequencer, blank tape and a deadline by which these must all be filled with music. The music for a scene, called a *cue*, is analyzed for its emotional content. What should the music express? Should it heighten the tension, make it funny, make the audience feel concern for one of the characters, or add excitement to a scene that is dragging just a bit? This is all within the capabilities of a sensitively written score. Anyone who has seen the movie *Jaws* understands what music adds to a scene. Music can make a scene work.

The mood of the music should suggest a rough idea of the approximate tempo. Then, by using either the click track book described above or the following formulas, a precise tempo that will exactly capture the hits in the cue can be selected:

Seconds=(60/BPM)*(Beat-1)

Beat=((BPM*Seconds)/60)+1

BPM=(60/Seconds)*(Beat-1)

For example, suppose you have a cue that lasts exactly 37 seconds. If you know you want the tempo to be approximately 95 BPM, you could use the second formula to calculate the length of the cue like this:

BPM seconds beats
((95 * 37)/60)+1 = 59.583333333333

The tempo of 95 BPM doesn't produce an even number of beats in 37 seconds. What if you change the tempo to 94?

BPM seconds beats
((94 * 37)/60)+1 = 58.966666666667

This is actually so close to 59 beats that it becomes completely acceptable to compose 59 beats (the third beat of bar 15) of music at 94 BPM for a 37 second cue.

If the length of the musical cue cannot be changed for some reason, such as when using some existing music to fit a scene, you can use the third formula to get a more precise tempo. You could also add or subtract a few beats until you found a length that worked at a nearby tempo.

Here are the same formulas using FPB instead of BPM (these can be used for any frame rate):

$$Seconds = (FPB/Frame\ Rate)*(Beat-1)$$

$$Beat = ((Seconds*Frame\ Rate)/FPB)+1$$

$$FPB = (Seconds*Frame\ Rate)/(Beat-1)$$

These formulas can be used either for film or video by replacing "frame rate" with 24 or 30 respectively. Once a suitable tempo has been found that causes certain beats to fall exactly on desired frames of the picture, the task of writing begins. Whether this is done by traditional means of pencil and paper or electronically with a sequencer and synthesizers, the idea is still the same—write music that synchronizes perfectly with the action on the screen.

If all of this math seems perplexing, you need not worry. Try it on a few timing calculations and it will become like second nature (assuming your second nature owns a pocket calculator). In each formula, you know two of the three variables in order to get the third (i.e., you know the time and tempo to get the beats, etc.). There are also a number of excellent software programs for personal computers that do most of the grunt work involved in making tempo calculations. Such programs are available for many different computer systems such as the Apple Macintosh, IBM PC, and even the Commodore 64. The hit points and overall duration of the cue are entered along with an approximate tempo. These programs look for any appropriate tempo that will align beats with the hits.

Figure 12.1
Film composing software can help a composer with the more mundane tasks of the trade.

Cue - the Film Music System
Courtesy of Opcode Systems.

It is critical for a composer to keep a careful log of the tempo or tempos of each cue. This makes it possible to move between cues quickly during composing without needing to recalculate the clicks for any given cue. You may wish to perform the tempo calculations for a number of cues at once and then write the music for these cues before going on to calculate the tempos for more cues.

If you are composing in a MIDI-based studio, you should know that many SMPTE-to-MIDI converters can store only one tempo map at a time, and the need to constantly reprogram the device can become a bit tiresome. Some SMPTE-to-MIDI converters can be programmed with MIDI System Exclusive messages by using a specially designed computer program or some of the available "universal librarians" that can store data from any MIDI device. This can save a lot of time over reprogramming each tempo map by hand every time it is needed, not to mention avoiding possible errors in programming complex tempo maps in the sync box.

SCORING WITH MIDI FILES

Scoring a film with a MIDI sequencer, just as in composing for a live ensemble, generally involves calculating the tempos prior to writing the actual music. Obviously, you need a basic concept for the music in order to estimate the desired tempo. You also must have the exact tempos chosen before being able to sequence to the picture.

Using a computer-based sequencer in conjunction with a film scoring assistance program has a wonderful added benefit: The MIDI protocol has a standard format called *MIDI Files* for exchanging files between any compatible sequencers. In addition to storing all the musical information about a sequence, MIDI Files can also contain accurate and complex tempo maps (tempos are stored in *microseconds* per beat, which are millionths of a second!). Some of the film-scoring software currently available can generate a MIDI File of tempos and tempo changes that can be read directly into a MIDI File-compatible sequencer. From there, you can continue to compose the music in the sequencer, but with every tempo change built right into the sequence.

The sequencer can be locked to video or multitrack tape with the calculated tempos stored internally, thus putting less importance onto a SMPTE-to-MIDI converter. Some sequencers offer direct SMPTE reading by way of special peripheral hardware. Others* use a MIDI synchronizing trick called "indirect time lock" that works by setting a SMPTE-to-MIDI converter to 60 BPM and figuring the tape location by the elapsed time on the converter. A growing number of MIDI sequencers now use a method of direct video synchronization call MIDI Time Code, or MTC. (See Chapter 20.)

THE SOUND OF ONE HAND CLICKING

Now that all the intricacies of click calculations have been examined, it should be pointed out that there are many composers who prefer to avoid the use of clicks altogether. Some argue that it makes their music less expressive, while others feel it simply isn't that necessary. There is validity in both of these statements (or I wouldn't have wasted all this paper explaining how to do this), although neither is an absolute truth. Some composers simply "feel" the tempo they want and find that many of the hits just work out by intuition or coincidence. Some film and TV composers do not care about hits and simply write music to express a mood for a certain number of seconds. By sustaining or fading the last note, there is no need for complete accuracy even on the length of the cue.

Perhaps these ideas should be combined with the use of frame-accurate music (not to mention sound effects which must be synchronized with absolute perfection) to find a blend of technique and intuition that works for any particular project or musical style.

After the music has been written comes the process of recording it. It is here that much of the muscle and magic of synchronization devices becomes most important. The music must be recorded at exactly the right tempo, or all the calculations made during the composition will have been in vain. In the next section, you will see how the music is fitted into the precise frame-by-frame action of the movies, starting with the composer's liaison, the *music editor*.

* Such as Mark Of The Unicorn's *Performer* software for the Macintosh.

MUSIC EDITING

THE MUSIC EDITOR

The person with the most pivotal role in getting music incorporated into a film or video is the *music editor*. Unlike the picture editor, whose sole task is to cut the scenes of the film together, the music editor performs a number of functions during the entire production. The composer and music editor work closely together during the creation of the score, and it is the music editor's job to provide the composer with everything he or she needs to actually write the music. The music editor may also supervise the composer's work to be sure it will fit in precisely with the film.

The music editor's role is virtually a summary of music post-production for film or video.

THE SPOTTING SESSION

"Spotting" is the process whereby the producer, director, film editor, composer and music editor get together with a *rough cut* (an incompletely edited version) of the picture and select the places to start and stop music. The film is viewed and the emotional content of each scene is discussed. If it is a film, it is typically viewed on a film editing table, often called a "flatbed" or "Kem" (for the brand name of a popular model of flatbed film editor; this is like calling all tissues "Kleenex"). A feature-length film can be made up of ten or more reels, so this process can take several days. A film footage counter is attached to the flatbed. The footages of important scenes are written down by the music editor and put into a "spotting list" of all the start and end points (notated in feet and frames) for all of the reel's cues. These will later be converted by the music editor into more precise timings when a final cut of the film is made. If the project is video, the picture is viewed on a TV monitor with an hours/minutes/seconds/frames counter visible on the screen.

The spotting session is usually the first opportunity for the composer to see the film from beginning to end and to come up with a musical concept for the picture. The music editor will use the "spotting notes" from the spotting session to create *cue sheets,* which are highly detailed descriptions of each scene that contains music with exact frame counts of every important action in the scene.

For film production, the soundtrack is recorded on a separate piece of 35mm sprocketed mag. It is synchronized with the film by lining up a mark on the mag with a mark on the film. Both marks are placed 12 feet before the first frame of the reel. Cryptically enough, the mark is called the "12 foot start mark." Once the mark is located on both the mag and film, they are locked together mechanically on the editing bed.

The footage counter on the editor is reset to zero at the frame in which the start mark occurs, so the first frame of the reel occurs at 12'00" (12 feet, 00 frames).

If music is to start right on the first frame of the reel, it will be listed as starting at 12'00". An audio beep on the mag track, called a *sync pop*, is heard at 9 feet before the first frame of the reel. A pop is also placed at the end of each reel to ensure that everything has stayed in sync while working with the reels.

The music editor and the film editor need to reach an agreement as to whether or not the first frame of the reel is considered frame number 1 or frame number 0. While some people may not think that a single frame matters, it does, especially with faster cues that frequently hit on visual events. This should not be an arbitrary decision. The first frame of a reel (or a cue) should be *frame 0*, unless the frame counter on the editing machine starts with a one. The reason for this is that no time has passed until a frame has moved by, thus making "frame 1" (the second frame of the cue) the first frame in time. There can be exceptions to this rule, but it should be agreed upon by everyone involved in the production.

TIMING THE CUES

During spotting sessions, it is usually not critical to create precise frame listings. These sessions are used to select the general areas in the film or video that will have musical accompaniment. In the next phase of production, the music editor and composer perform a more precise timing of each reel. The composer will select the exact frames for music to begin and end, based on the rough notes made during the spotting session. Each cue is given an identification number based on the production reel number and the position of the cue within the reel. All cues are labeled with the letter "M" to indicate "music." For example, the first cue on the first reel is labeled "1M1," the second cue is "1M2," etc. The first cue on the second reel is "2M1," and the tenth cue on that reel is "2M10." Additionally, the composer may wish to add a more descriptive name to the cue, such as "10M7 — 'The Dark Alley.'"

After the cues have been selected, the music editor goes through the scene and marks the exact frame number for each film edit (or "cut," as they're called), sound, action, and line of dialogue (to help insure that the composer won't write a saxophone solo on top of "and the murderer is..."). This produces a cue sheet (see Figure 13.1).

After the cue sheets have been prepared by the music editor, they are given to the composer to use while writing the music. Music editors will include varying amounts of detail for the actions listed in the cue sheet,

```
"HEART OF DIXIE"                            1/21/89
MUSIC TIMING NOTES                  PAGE 1 OF 3
REEL 8  SCORE

8M1                        AIKEN IN THE PARK
             AIKEN HAS JUST TOLD MAGGIE SHE'S PREGNANT.

FEET      TIME
639.10             AIKEN MOVES OF BENCH TO FACE MAGGIE.
                   AIKEN: "THAT'S WHY I WANTED TO SEE YOU."

647.7     0:00.0   MUSIC STARTS AIKEN LOOKS MAGGIE IN THE EYE.

647.1     0:03.2   AIKEN: "I'M LEAVIN' RANDOLPH."

650.8     0:05.10  CUT–C.U. MAGGIE.

651.1     0:05.17  AIKEN O.S. : "I WANTED TO SAY GOODBYE."

653.12    0:07.14  CUT – C.U. AIKEN.
```

Figure 13.1
A typical cue sheet listing important visual elements for the composer.

from simple descriptions to mini-novels. In the transition from spotting notes to cue sheet, there is a significant change. While spotting notes are listed in feet and frames from the beginning of the *reel* (and 12 feet before the beginning of the first frame of action), cue sheets are measured from the beginning of each *cue*.

PREPARATION FOR THE SCORING SESSION

Whether for film or video, most picture recording sessions are done while watching the picture (a process called "working to picture"). The music editor is the person responsible for having the picture properly prepared for the session. Depending on the picture's budget and on the sophistication of the recording studio (which is also dependent on the film's budget), either film or video tape

will be played back during the recording. While the use of video for film scoring has grown over the past few years, film is still a popular option for its sheer visual impact and availability in many better recording studios. The music editor attends every recording session (electronic or acoustic) to supervise the process and ensure correct lock-up between the music and picture. The music editor keeps a log sheet of cues as they are recorded along with their final timings and other notes, and may perform other tasks as well. These tasks might include operating special metronomes or other click and synchronization equipment, timing cues to double check their accuracy, and functioning as a liaison between the composer and the rest of the production team.

EDITING THE MUSIC

For film work, the music editor has the final music mixes transferred from 1/2" 4-track tape (usually) to mag on 2000' reels, each day after they are completed. Three of the tracks will contain various elements of the music and the fourth is for the sync code. Using a felt-tip pen, he or she will mark the start of each cue directly on the magnetic side of the mag with its footage and identification number to catalogue and organize them. The cues are then edited, removing the extra space before and after each cue. Video productions are catalogued by SMPTE timings and logged on paper or into a computer.

After the mixes are transferred and catalogued, the editor builds "units," which are reels of mag film that run the entire length of each film reel. Ordinary blank film is placed between the music cues on the music unit to fill in the gaps where there is no music.

There are times when the music editor's job goes beyond the technical to become quite creative. If certain cues don't work well, if the picture is recut, or if music must be added to a scene and there was no time for the composer to write any, the music editor is quite often called upon to re-edit other cues to make them work as new material.

THE DUB

When the music editor is finished cutting all of the music cues and matching them up with the original frame numbers from the film (and if the composer's tempo calculations were correct and all of the synchronization equipment worked during the recording and mixing), there should now be mag reels with all the music cues (and hits within each cue) that line up exactly with the picture reels.

In addition to music, other editors have assembled reels of sound effects and dialogue. There may be several reels of each for every reel of picture. In a typical dubbing session (the term for motion picture sound mixing), there are three engineers: a dialogue mixer (who is also the head engineer and runs the whole show), the sound effects mixer, and the music mixer. Each person sits in front of a section of a special mixing console designed for doing film sound mixing. The console is usually in a large studio called a "dubbing theater" or "dubbing stage" with a projector and screen or a video monitor. Usually, a SMPTE display or feet/frame counter and a large audio level meter are found above or below the screen. It is here that everything gets mixed together into a single track—either mono, stereo, and with or without a surround channel, depending on the project's budget and the film's format.

The composer may go to this final mixing session, though he or she may be asked to keep all opinions to him- or herself. This is the first time all the elements

are brought together for everyone to see. It may be decided that a particular cue does not work well with the picture, in which case it is simply omitted with no fanfare or second thoughts. Since music most often plays a relatively subordinate role in a film, this should not be viewed as a failure by a composer, but simply an aesthetic decision made by non-musicians as to whether or not a scene in the picture needs music. Once the final dub (the actual final mix) is completed to the producer's and director's satisfaction, the composer's role in the production is complete.

Low budget projects may not have a music editor, in which case the composer may need to take on all of those duties up until the final editing and dubbing. Understanding the process of putting music to picture puts a composer in a better position to do the job right the first time and avoid costly mistakes. While video is a very different medium, the process of composing and editing the music for it is quite similar. All timings are done with 30 frame SMPTE time code.

THE DIGITAL METRONOME

For the last few decades, film score click tracks have been produced with a device called a *digital metronome*. These devices get their name not from the use of computer circuitry (they've been around longer than computers), but from the use of numerical digits entered into the front panel to set highly accurate tempos. The most popular digital metronome is from the German audio company Urei, although there are others as well.

All digital metronomes work in the same manner: they are calibrated in frames per beat (FPB) in increments of an eighth of a frame. Tempos are entered as a three-digit number on the front panel. The first two digits are the tempo in FPB. The third digit, usually separated from the first two numbers with a decimal point or dash on the machine, is eighths of a frame to add to the tempo. For example, a tempo of 60 BPM would be displayed as "24-0" on a digital metronome, which would be pronounced as a "twenty-four oh" click, meaning twenty-four frames and "0" (a.k.a. zero) eighths. The next available tempo on a digital metronome is 24-1 FPB (a "twenty-four one" click) for 24 and one-eighths frames per beat (which is equivalent to 59.69 BPM). This is followed by 24-2 FPB, etc. The tempo decreases (remember, the more frames in a beat, the slower the tempo) to 24-7 FPB, then goes to 25 FPB and so on.

Digital metronomes like the Urei are started by pressing a button on the front panel. At a traditional orchestral scoring session, this job often falls to the music editor, who sets the correct tempo (based on the composer's score) and presses the start button by hand while watching for a warning signal on the screen This generates a loud, sharp click at the set tempo which is sent to the headphones worn by the musicians. Some might consider it odd that, with all the precision and automation available today, and with all the care that goes into getting a score to be frame accurate, the metronome is started by someone watching the movie and then pressing a button. Some traditions die hard. (So do some music editors, who miss pressing the button at the right moment.)

With the popularity, power and simplicity of SMPTE time code, the digital metronome is no longer the only device used for generating click. The ability to program tempos in BPM or FPB at various frame rates for video use, multiple tempos within a single cue, accurate and automatic start triggering on a given frame, and the ability to generate click, timebases, and MIDI sync all at once make the newer generation of tempo machines and personal computers a better choice. Still, the wheels of show business turn slowly, and the techno-institution of the digital metronome still finds much work.

Using Metronomes

A click generator ("techno-ese" for metronome) is needed anytime live musicians are used for film, video or TV music or anytime accurate tempos are needed. Most electronic metronomes (digital or otherwise) intended for professional use have a line level audio output that sends out the click. A good electronic metronome will begin clicking at a specific frame number, which can be programmed into it.

One Bad Click Can Ruin Your Whole Day

Anyone recording music to click, be it for film, TV, recordings, commercials, or whatever, must always be careful of one thing: the click must be loud enough for the musicians to hear over the music, but it must never leak from their headphones into the microphone. (It would be depressing to count the number of hours that have been spent splicing audible clicks from recording session tapes done with a click track.) There are a few tricks to ensure that such a tragedy does not befall you in your lifetime:

1. Make sure that everyone keeps their headphones on with both phones on their ears. A lot of musicians like to slide one headphone off so they can hear themselves better, but this is one of the major causes of click leakage.

2. If some musicians do not play on a particular cue and leave the room while it is being recorded, be sure that their headphones are *unplugged*. Do not depend on the musicians to remember to do this. Assign this task to one of the engineers or the music editor. If everyone wishes to use only one side of their headphones, pan the headphone mix to only one side.

3. Here is a simple trick that will make the click get louder as the music gets louder, and lowers the click level during quiet sections: Feed the audio click from the metronome into the audio input of a "keying" audio gate or compressor. Then feed the monitor mix of the music into the "key input" of the same device. As the music input level increases, it will amplify the clicks proportionately.

4. If clicks are being recorded onto the master tape (always a good idea in the event something happens to the time code or there is a need to overdub a new part and the metronome isn't available), be sure to skip a track between the click and any audio material, as there is often a slight amount of crosstalk onto adjacent tracks of analog multitrack tape.

Streamers And Punches

02:10:13:58

There are two simple visual aids that are frequently used to help give a warning of an upcoming event on a film or video tape. A *streamer* is a diagonal line that is scribed over several frames of film (or electronically superimposed onto video tape) previous to an important event. When played back, a streamer appears as a line moving from left to right on the screen. At the end of a streamer is a *punch*, which is a flash of light indicating the exact frame of the event. Punches are usually placed on the first beat of the count-in, the first beat of the music, on any important "hit," and at the point where the music should stop.

They are created by using a hole puncher in the center of the frame. On video tape these round flashes are simulated with special video equipment. Each punch is preceded by a streamer. The conductor watches for the streamers to ensure that he or she will start or stop the music or make a significant transition on time.

The streamers and punches are added to the film or video by the music editor based on instructions from the composer. As the composer completes each cue, he or she will tell the music editor the tempo of the cue (in FPB) and "how many free," meaning the number of count-in beats. The editor uses a specially marked strip of 35mm film called a "click egg" that helps him or her physically place the streamer's diagonal line into the film with a sharp-pointed object and colour it with a yellow, green, or red marker. They also may mathematically calculate the first frame to mark by multiplying the tempo in FPB by the number of desired warning clicks and subtracting the result from the starting frame of the cue. Computer software is available to recreate streamers and punches onto video tape or any video monitor

The first streamer (yellow) appears just prior to the first *warning click* (film lingo for count-in clicks), giving the conductor a chance to prepare. A punch will occur at the same time as the first warning click. The count-in proceeds, usually for two measures (or one measure if the tempo is very slow). A green streamer appears just before the music is to begin, and another punch appears on the first beat (and frame) of the music. This is a visual confirmation for the conductor that the number of count-in beats was correct, and the music is about to begin.

The music is then recorded. Additional streamers and punches may occur on important hits, those significant moments in the scene that have been captured musically. There will be a final streamer and punch, this time in red, to indicate when the music should end. It's not uncommon for a cue to end with the last note or chord held indefinitely. If the composer has counted the time the last note should hold, the click will stop, and the conductor will watch for the last streamer to indicate that the music should stop. Even in an electronic scoring session with no musicians, the streamers and punches are a visual confirmation that everything is proceeding correctly.

Figure 13.2
Film frames showing a streamer (top) and punch (bottom).

CONDUCTING TO PICTURE

Conducting a musical ensemble or a full orchestra is a serious and demanding task. It is usually the composer who must change hats in order to conduct the group at the recording session. Conducting for a film score both adds and removes some of the complexities inherent in the conductor's job. If the cue is being recorded to click with a digital metronome, the traditional function of the conductor, keeping the tempo, is not as demanding. The conductor still must cue entrances for musicians and decide on the dynamics of the performance. It is the conductor who, after rehearsing a cue with the ensemble and deciding that

everything is satisfactory will ask the engineers to roll the tape and record the cue. After the cue is recorded, the conductor decides if the performance was acceptable or if another take must be recorded, and may listen back to the tape in order to decide. If all is well, it is time to go on to the next cue.

If some cues in the score are not being performed with click, then the conductor takes on the more traditional role of providing the tempo to the group. The conductor works while watching the picture projected on a screen behind the orchestra or on a video monitor by the podium. By looking for streamers and punches, the conductor can catch the scene's hits while keeping the tempo as fluid and expressive as desired.

It's not unusual anymore for a score to consist of combinations of orchestral musicians, live-performed synthesizers, and MIDI-sequenced parts. Of course, live synthesists can play to a click just as any other member of the orchestra. But if sequencers are used, and their parts are not overdubbed at a later session, then both clicks and MIDI clock must be provided to synchronize the live performance with the sequenced parts. A number of click generators have the capability of outputting MIDI sync messages along with the click, allowing sequenced parts to be recorded simultaneously with the rest of the orchestra.

Even when playing to a click, a good conductor can make the difference between a mediocre and an inspired sounding performance by an ensemble. Since the conductor is the composer in almost every case, it is highly recommended to find a book on conducting or take a few conducting lessons. The difference this can make in a recording session is surprising.

A Final Tale

It's very common to end a cue with a sustained note or chord that will fade away in the final mix. This is sometimes called a "tail." It is important to leave extra time at the end of a cue for this fade. The sound engineers that perform the final mix for a film or video prefer to perform the fade themselves as opposed to having it done for them. In any cue with a final sustained note or chord, hold the sound for several extra beats or until the ending punch if one has been made. The click can be stopped during this time if desired. If the score is being conducted to picture, watch the picture to make sure that the last note has lasted past the end of the scene.

[Refusing to give metronome guidance] "Idiot! Do you think I want to hear my music always played at the same speed?"

Johannes Brahms,
Walker (ed.), Robert Schumann: The Man and His Music (1972)
(note: Brahms never made it as a film composer.)

SMPTE AND VIDEO PRODUCTION

The first part of this book describes ways to use SMPTE as a means of syn–chronization in the recording studio. By now you should have a fair idea of SMPTE's amazing power and ease of use, as well as the basic theory of its operation using hours, minutes, seconds and frames. However, it is in film and video work that the real power of SMPTE time code comes alive. Since SMPTE is calibrated in frames, it has a direct reference to the physical nature of both film and video.

Machines able to read the SMPTE code from a video tape can be used to synchronize sequencers, drum machines, computers, sound effects, slave multi-track recorders and mixing console automation in exactly the same way as de-scribed previously with multitrack tape. The time code used in video and film production is the same, standard SMPTE code.

This section covers the ways in which composers and other post produc-tion people work with video and SMPTE time code, and how sequencers and other clock-based devices can be integrated with a video system for compositional and other sound applications. You will start by considering how film images get transferred onto video tape for post-production or broadcast use, and how this process affects a composer's work.

FILM-TO-VIDEO TRANSFER

For a great many years, composers writing music for film would get a print of the film and view it with a special viewer—a Moviola—while writing the music.

While not entirely unused today, these large machines have given way to a more practical and modern approach: watching the film on video tape with a VCR while composing. This certainly makes life much easier for everyone involved (with the exception of the people who make Moviolas).

The first thing to consider is how a film is put onto video tape. Remember that film runs at 24 FPS while video zips along at 30 FPS. If you were to take a video camera and try to tape the image directly from of a movie screen, you would be disappointed to find the video image rolling around with big bands across it, due to the "out of sync" relationship between the two media. So how is it done? The answer is: *very cleverly*.

Figure 14.1
A Flatbed editor, used by film and sound editors for viewing and listening to film.

There is a discrepancy of 6 frames every second between film and video (24 vs. 30). Using a very special device called a "Rank Telecine" (for the name of the

company that makes it), a *transfer house* (a company that specializes in film-to-video transfers) electronically scans each frame of the film and transfers it onto video tape. To compensate for the difference in the frame rates, *every fourth frame of the film is duplicated onto the video tape* in a process called a *3:2 pulldown*.

Figure 14.2
Film is transferred to video tape by duplicating frames.

Images recorded on video tape are composed of several hundred tiny lines of light and dark, which are displayed onto the video screen. Each video tape frame is actually made up of two *fields* which are *interlaced* (blended together) to create the image on the TV screen. One field provides all the "even" lines on the screen and the other provides the "odd" ones. The extra frames required to transfer film to video are created by putting a film frame onto both fields of a video frame and the first field of the next video frame. By copying film frames onto two then three fields respectively during the transfer, the six extra frames needed to fill a second of video tape are generated, causing the final product to run at the standard video rate of 30 frames per second. The end result is a video tape copy of the original film material that is visually indistinguishable in content.

ADDING TIME CODE

While a film is being transferred to video, or when a video tape gets copied for use by an editor or composer, SMPTE time code is recorded onto one of the audio channels of the tape copy. A master synchronizing device is used to coordinate the operations of the master film or tape and any slave video recorders being used to make the duplications (called "dupes"). A starting frame number is entered into a SMPTE generator that is then locked to the master synchronizer, thus guaranteeing that the frame numbers in the duped copy exactly match the actual frames of the original tape. The end result is a tape with a video image, and SMPTE time code on one of the audio tracks. If there was an audio track on the master film (on a separate reel synchronized to the picture reel) or tape, it may also be transferred to the dupe on another of the tape's audio tracks.

A composer or other post production person can now use this duped video tape to calculate tempos, compose and sequence while viewing the picture, and, more importantly, lock sequencers or audio tape machines for recording music to the video by using the SMPTE time code on the video tape's audio track. The time code on the video tape becomes a universal reference for everyone working on the film, either editing, scoring, or dialogue re-recording and sound effects.

FRAME RATES AND SMPTE FORMATS

By now, you have learned that different media formats use different frame rates for recording and playing back images. Film is 24 FPS, while video is 30 FPS in the United States and Asia, and 25 FPS throughout most of Europe. There are time code formats that match each of these rates for use in synchronization. There are several other factors that add more complexity to the synchronization of visuals at various frame rates. Indeed, there are other formats that are in common use today. These are also sources of great misunderstanding and confusion for a large number of people. Most SMPTE generators can be set to generate any of the SMPTE formats described below.

"30 SOMETHING"—SMPTE TIME CODE FOR VIDEO

Here's a little riddle: When is 30 not 30? No, the answer is not the age given by a 39-year-old wishing she or he could turn back the clock. The answer is: when you are speaking about the true frame rate for video tape. A very brief history lesson is perhaps in order here.

When video became standardized, it ran at exactly 30 frames per second and used 60 cycle household AC as a reference for speed accuracy. When colour video cameras were invented, it became important to find a way to make the new colour TV broadcasts compatible with all the existing black-and-white TV sets that had bloomed in America. The solution was to leave the black-and-white signal alone and make colour an additional signal that came after the frame had been sent. This was achieved by slowing the frame rate of the video tape ever so slightly to 29.97 frames per second in order to leave the extra time needed to add the colour information.

This may seem like an insignificant difference, but when working with video, absolute accuracy is a must. From this slight speed change comes a number of potential problems, all of which are avoidable if you remain aware of how you work with SMPTE time code in video scoring and post production. Since the video is moving at less than 30 FPS, the SMPTE time code that may be recorded onto a video tape will also be played back at the slightly slower speed. This is all right unless your click calculations were based on something else.

Depending on to whom you are talking, the frame rate for video and video time code may be referred to as "30" or "29.97." At times someone may refer to "59.94" as a frame rate for video or SMPTE. Don't worry, it's all exactly the same thing.

In order to preserve an exact 30-to-24 ratio when film is transferred to video, the film is actually slowed, ever so slightly, to 23.976 FPS, and every fourth frame is duplicated as discussed earlier. This means that the action seen in films transferred to video is running just a bit slower than normal, but not enough to

be noticed. When the editing and post-production sound are completed and transferred back to mag, they are sped up slightly to return to the norm of 24 FPS. The changes in speed and pitch are so slight they cannot be heard, but all timings, calculations and synchronization will be accurate to the frame.

There are various ways to compensate for this slight "inaccuracy" of video's frame rate. SMPTE time code comes in a variety of "flavours," or *formats*, as they are more correctly called. Within the digital domain of the SMPTE time code system, there is a special "flag" bit to tell any time code reader in which format the code was recorded. Any SMPTE reading device should have no trouble reading any format and most often can tell what format it is receiving automatically.

In this section you will look into the basics and correct use of each SMPTE format and how to determine which one is needed for any given situation.

Non-Drop Frame SMPTE Time Code

SMPTE time code labels each frame of a video tape with a "frame number" (0 through 29), and increments its time counter by one second every thirty frames. If video tape moved at exactly 30 frames per second, then a SMPTE time code generator would update its time counter *exactly* every second. However, since video tape is actually moving at 29.97 frames per second (slightly slower than the expected 30), SMPTE time code is being replayed from the tape just slightly slower than normal clocks. For example, if, at exactly 12:00, you started a video tape with code and compared the SMPTE numbers with the clock on the wall, they would very slowly begin to drift apart. The SMPTE time code would fall slowly behind the real time.

How much slower is SMPTE to the rest of the world? To be exact, 1.8 frames per minute, or 108 frames per hour which comes to approximately 3.6 seconds longer than real time. This is certainly enough to cause a problem if it is not expected. But don't worry yet. You will see that none of this is a problem if used properly.

SMPTE time code that numbers every frame of the video tape sequentially is called *non-drop frame SMPTE,* or *non-drop* for short. It may sometimes be abbreviated as "ND" or "NDF" on synchronization equipment.

Non-drop time code sequentially numbers each frame of the video tape but does not stay in time with real clocks. Some video recorders record non-drop time code directly onto the tape as they are shooting, and each frame gets a unique SMPTE frame number.

Drop Frame SMPTE Time Code

Another format of SMPTE time code has been created that eliminates the time drift problem of non-drop SMPTE code on video tape. It is called *drop frame* SMPTE time code. It is sometimes referred to simply as "drop" by the busy industry types who like to boil phrases down to their essence. SMPTE readers that visually indicate incoming time code formats may show "DF" or "DROP" in their displays.

Unlike non-drop frame time code, a drop frame time code display will match the time on a real clock exactly. This is achieved by occasionally skipping frame numbers to compensate for the 18 frame drift that occurs every 10 minutes at 29.97 FPS. Specifically, drop frame *skips frame numbers 0 and 1 at the beginning of every minute that is not a multiple of 10.*

Think of drop frame time code as the opposite of leap years. A leap year adds an extra day once every four years to compensate for a slight inaccuracy in

the way time is measured with the calendar (years are not exactly 365 days long). By skipping two frames from nine out of every ten minutes, the slow drift between SMPTE frame numbers on the video tape and real clocks is eliminated. This is not cutting frames from the picture, but skipping frame numbers in the SMPTE code. For example, here are some consecutive frame numbers using drop-frame time code:

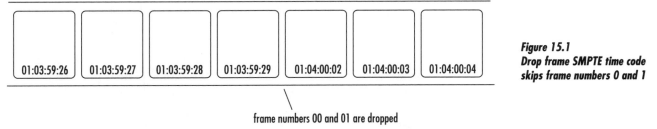

| 01:03:59:26 | 01:03:59:27 | 01:03:59:28 | 01:03:59:29 | 01:04:00:02 | 01:04:00:03 | 01:04:00:04 |

Figure 15.1
Drop frame SMPTE time code skips frame numbers 0 and 1

frame numbers 00 and 01 are dropped

The time code recorded onto the video tape does not number the frames in perfect sequence, but it does match the clock on the wall. This makes click calculations based on 30 FPS work perfectly.

DROP FRAME VS. NON-DROP FRAME—THE BATTLE RAGES

Both drop and non-drop SMPTE formats are used with video tape post-production. Synchronization problems can definitely occur if one mode is expected but the other one used. All SMPTE readers can recognize and respond to either format. However, if a composer has calculated tempos based on "real time" (e.g. "I need 3 minutes, 12 seconds, and 18 frames of music here") and locks to non-drop code, the music will drift from the picture and end up a bit too long.

The decision to use drop or non-drop SMPTE code on a video tape comes down to one basic question: Is the video tape being made for broadcast on television or as a video, or is it a film transfer for post production with the final product being film?

Film transferred to video tape with the intention of being broadcast on TV should use *drop frame* SMPTE code. This format will give the most accurate timing (a television show for a network is allowed a margin of error of only a second or two in overall length). As a composer working with a video tape that has drop frame time code, you will be dealing in "real time" with no drift. All calculations can be made on this basis, making your life somewhat simpler (if, in fact, you are scoring a television movie or show, your life will probably not be simple at this time). Any time you are working with a non-synchronized, free running sync source such as a digital metronome or non-SMPTE click or MIDI clock generator, you should also use drop frame time code. Since the timings from the tape will match "real time," so will the music itself when it is recorded to picture.

In film scoring, when the video cassette is being used as a reference during composing, non-drop frame time code is normally used. In this mode, there are no missing frame numbers, and while the time code on tape will not match "real time," cue sheets use frame numbers derived from the video tape. Using these frame numbers from the time code will not cause any sync problems when recording to picture *as long as the time code from the video tape or another non-drop frame time code source is used*.

When a composer receives a video cassette of a project for which there is to be music, he or she is often given the option of choosing the format of the time code that is recorded (or "striped," as it is often called) onto an audio track of the cassette. Careful discussions with the transfer house will help to avoid the pitfall of receiving a tape with the wrong time code format on it.

24 Frame Time Code

Motion picture film is run universally at 24 FPS. There are no significant exceptions to this. Some European movie theaters run their projectors at 25 FPS, thus matching their video speed and making film-to-video transfers very simple. But this slight change does not have any bearing on post-production sound work, which is always done at the normal 24 FPS rate.

There is a little-used SMPTE format that is based on a frame rate of 24 FPS, the speed of theatrical movies. This time code is generated by some 35mm movie cameras and can be recorded onto video or multitrack tape. The typical use for this format is locking a multitrack recorder to a film camera in order to record the production sound (the sound being created on the set). This way, the tape deck can later be locked directly to a film projector that also generates 24 FPS SMPTE for additional post-production recording and mixing. The primarily use of 24 frame SMPTE is for recordings of concerts being filmed live.

25 Frame Time Code

In Europe there is yet another format in use. A 25 FPS SMPTE time code format is used to match the video frame rate that is used throughout most of the continent. As opposed to video in the U.S., both black and white and colour video run at 25 FPS, so there is no need for drop frame vs. non-drop frame codes. Lucky them. The organization that maintains video technology standards is the European Broadcast Union (EBU). This organization performs functions similar to those of the SMPTE organization in the U.S., keeping tabs on the SMPTE time code formats in the U.S. and other non-European countries.

30 Frame Time Code

This format is not used often in video production. It was originally used with the black-and-white video tape's frame rate of exactly 30 FPS. Today, its use is mainly restricted to recording studios and home MIDI studios for non-video work. Many of the SMPTE devices made by popular electronic musical instrument companies (Roland, Yamaha, Opcode, Garfield) can read other video frame rates, but also generate and read the less-used 30 frame non-drop. Some video post-production engineers may say that true 30 FPS SMPTE is not "real" SMPTE. But with proper usage, there will be no problems locking together a multitrack tape machine using this format simultaneously with other SMPTE formats on video if the synchronizer used recognizes both formats.

Vertical Interval Time Code (VITC)

The SMPTE time code that is used for all audio and video tape is more formally called *longitudinal time code*, or *LTC*. It is recorded and played back just like any other sync signal on one audio track of the video tape. There is another format of SMPTE time code that, with the proper (though still somewhat expensive) equipment, adds even more power to a video production environment for music or sound effects work. It is called *Vertical Interval Time Code*, or VITC (pronounced "vitsee") for short.

Like LTC, VITC can be generated in drop frame or non-drop formats. The

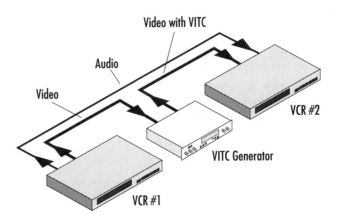

Figure 15.2
A VITC Generator adds time code to a video signal.

difference between LTC and VITC is that, instead of being recorded onto one of the video tape's audio tracks, VITC is recorded onto an unseen part of the video image called the "vertical interval." Sometimes, when the picture on your TV loses its horizontal hold and rolls up or down, you may have noticed a black band between the top and bottom of the frame. This area is the vertical interval, and it is used by the picture image to line itself up with the boundaries of the TV picture tube. It is in this small band between the picture frames that VITC is recorded. A special SMPTE time code generator with VITC capabilities is used to generate the time code and merge it with the existing video image onto the working video tape.

In order to use VITC, a special VITC-to-LTC converter is needed (did you think you were going to get more power without having to buy more equipment?).

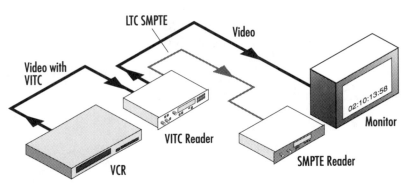

Figure 15.3
A VITC reader extracts SMPTE time code from a video signal.

A VITC converter "separates out" the SMPTE time code from the vertical interval of the video signal. It then sends the video signal to be displayed on any TV screen or monitor, and outputs LTC to any standard SMPTE-reading device. Often, there may also be LTC on audio tracks as well, depending on the discussions between the composer and the transfer house that prepares the video tape. This ensures that the time code on the tape can be used in the event there is no VITC equipment available.

VITC, SO WHAT

VITC has one major advantage over LTC in any post production, sound effects or scoring work. The process of spotting a video for either music or sound effects involves putting together a list of feet and frame numbers that correspond to important moments in the picture. Most spotting for films is done with a Moviola or flatbed. If spotting is done with video tape, listing time code numbers can be done by feeding the SMPTE time code from the tape into a SMPTE reader and freezing the tape on a desired frame. The problem is that the time code stops whenever the tape does. Although a normal LTC SMPTE reader may display a frame number while the tape is paused, this number is completely unreliable.

The playback head inside a VCR spins 59.94 times per second, twice for each frame. While the tape is paused, the spinning head continues to scan and play back the current frame positioned over the head. It also continues to read the VITC code (if it is present on the tape) and send it out along with the rest of the video signal. A VITC reader will continue to receive the current frame number even while the VCR is paused. Accurate and reliable frame numbers can be read

from a SMPTE reader or catalogued by an automatic cue event cataloguing system. The process is as simple as finding the frame to catalogue, pausing the tape, reading the frame number, and then moving on.

VITC is converted into LTC by the VITC reader. Once it is in LTC format, it functions identically to any other LTC time code, drop or non-drop, with the exception that it can send the same frame number over and over again (if the tape is paused). A few SMPTE readers may not be capable of reading the same frame number more than once in a row, so check to be certain that the SMPTE reader you are using can operate with VITC.

"WIDEBAND" TIME CODE

You will occasionally find a reference to "wideband" SMPTE time code. This is not a different time code format. It is a technique that allows certain high-quality SMPTE devices to read LTC code at very high or very low speeds. This makes it possible to read code while a tape (audio or video) is in fast forward or rewind, or being played in slow motion. For example, the sequencer in New England Digital's Synclavier system (a very expensive, high-end audio workstation) can lock to SMPTE and record sequences at speeds as slow as 3 frames per second.

The need for wideband time code is rare, but as SMPTE devices become more elaborate and intelligent, this may become a more important function.

"God, it's an empty feeling watching a movie without any music!"

Henry Mancini

SYNCHRONIZATION WITH SMPTE

ne of the great pleasures found in working with a video tape containing SMPTE time code is the ability to compose, sequence, and even record the music while synchronized to the video. Just as a time code signal recorded on one track of a multitrack recorder becomes the master clock for a MIDI system in the recording studio, a video tape with SMPTE becomes the master clock in a music system for scoring music to picture. As shown in the diagrams that follow, the system can be as simple as a sequencer, a SMPTE-to-MIDI converter, and some electronic instruments, or can be more elaborate to include a multitrack tape recorder as well.

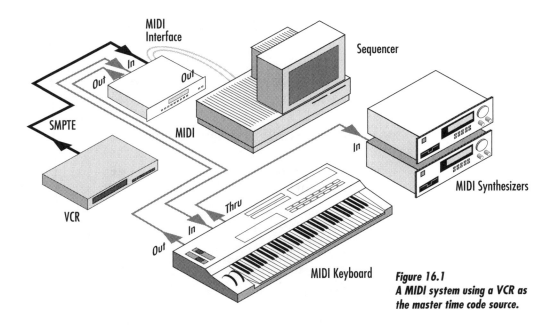

Figure 16.1
A MIDI system using a VCR as the master time code source.

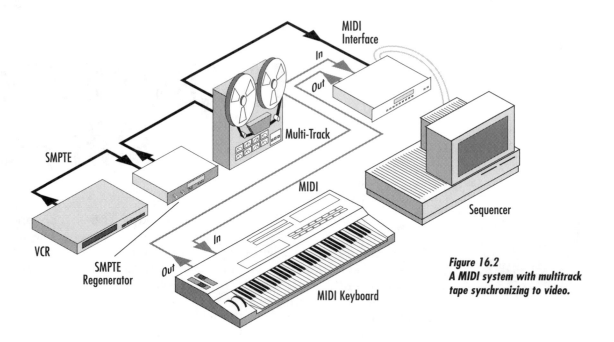

Figure 16.2
A MIDI system with multitrack tape synchronizing to video.

The goals of such a system are:

⊛ Composing while watching the picture and being perfectly synchronized to it.

⊛ Recording music while locked to picture to ensure accuracy of all timings.

⊛ Using both electronic and acoustic instruments by including a multitrack recorder.

⊛ Synchronizing all the elements of a studio to the video image without expensive tape machine synchronizers.

⊛ Composing at home to picture for recording later in a larger studio environment.

Many of the concepts regarding multitrack synchronization can be directly applied to work in film and video scoring using SMPTE. A sequencer in its external clock mode locked to a multitrack with SMPTE will operate in the same way when locked to a VCR with a video that has a SMPTE track on it. A number of elements and concepts must now be added to what you already know.

This section covers the process of adding music and audio to video in great detail. You will learn the exact techniques and systems used to do post-production sound at home or in a studio. You will also learn about many of the conventions that have become standard over the years that are still in use. Old habits do not disappear overnight; they are adapted for use with newer technology. If you plan to work with film or video, you will be working with film makers, directors, transfer houses, editors and production facilities. Understanding the conventions that they have come to expect from a composer will help to eliminate some of the problems that new or inexperienced composers often encounter. More experienced composers should find some new pieces of information about recent technologies being used in music for the screen.

VIDEO TAPE FORMATS

Before going further with descriptions of working with SMPTE and video, here's a quick look at just how picture and sound are recorded on video tape.

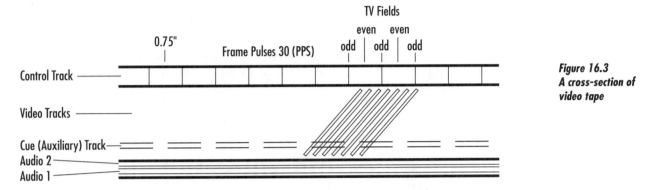

Figure 16.3
A cross-section of video tape

Unlike audio tape machines, which have stationary record and playback heads and pull the tape across them, video machines have spinning heads that scan the tape in a diagonal direction while the tape moves by.

The video tape has discrete areas used for specific purposes. The main area, taking up most of the width of the tape is used for the picture. This is where the actual frames are located. They are divided into fields labeled as "odd" and "even." A video frame is actually made up of several hundred lines that are drawn onto the TV screen with an electron beam. When a frame is scanned from the tape onto the TV screen, it is done by first sending all of the odd lines (Field 1) followed by the even ones (Field 2). The tape advances to the next frame and redraws the next image over the current one.

Along the side of the tape are the audio tracks. There can be one, two, or four such tracks, depending on the tape format and the video recorder. In addition, there is a *control track* which is used internally by the VCR to electronically align the tape properly with the heads.

There are four tape formats in common use today: Beta, VHS, 3/4" and 1".

BETA SP

This system was developed by Sony in the 1970s. It was one of the first popular home systems sold throughout the world. Most units have stereo audio tracks with "hi-fi" or "linear" (when the hi-fi mode is turned off) modes, though some are monaural only. While Beta has been virtually abandoned in the home market, its size, superior image quality and faster tape handling mechanism keep it popular for video editing, on-location shooting, and news video production. Most Beta VCRs can run at one of two speeds. The slower speed is sometimes unreliable for recording and playing back SMPTE time code and should be avoided for video sync work.

VHS

This was the major rival to Beta in the home market. It is by far the most popular format for consumers and is in wide use for sports, news and other professional video productions. It, too, has stereo audio in linear or hi-fi modes.

slower tape handling mechanism than the Beta format. While this is of little consequence to the average user renting movies, it can become a bit of a nuisance for the composer needing to watch a scene over and over. There are some professional grade VHS decks available with faster start mechanisms. VHS VCRs can usually run at one of three speeds. The slower speeds can be unreliable for SMPTE time code and are best avoided.

3/4" U-Matic

This is the workhorse video format for low-to-middle budget video facilities, although it is not typically found in the home. Its video quality is closer to that of 1" "broadcast quality" video. Most 3/4" video machines also have 2 channels of audio, though some 3/4" machines have a third audio channel especially for SMPTE code called the "address track." Three/quarter inch recorders do not come with the hi-fi channels found on the home units.

1" Reel-to-Reel Video

This is the professional standard for video recording systems. It is used by high-end production facilities around the world. Much of the video made for commercial and network broadcast is recorded or edited using 1" video tape reels. Most 1" machines have four audio tracks and a fifth address track for time code. Some 1" video recorders also have built-in SMPTE generators and readers.

Hi-Fi Audio

As mentioned previously, many home VCRs in both Beta and VHS formats include hi-fi audio as a switchable option. There is a noticeable improvement in the sound quality with the hi-fi mode turned on as compared with the normal linear mode. Hi-fi is not a noise reduction system like Dolby or dbx. Instead, the audio signal is recorded on the video portion of the tape along with the video signal using the video record heads with a special process called "FM encoding." This process uses the same principles as your FM radio to record and play back sound without adding tape hiss.

Since the hi-fi tracks are recorded onto a different part of the tape than the normal audio tracks, it is possible to record different material on the linear and hi-fi audio tracks. Unfortunately, only a few VCRs offer this capability or have separate audio outputs for the hi-fi tracks. There is an occasional problem using the hi-fi tracks on some VCRs to record SMPTE time code. Because the rotating video heads are used for the hi-fi tracks, the time code can sometimes get scrambled and unreliable, although this seems limited to older and less expensive video recorders. Before depending on the hi-fi track of your VCR for SMPTE time code, get a test tape from the production company and try it with the SMPTE devices you will be using.

PLACE YOUR ORDER

When a composer requests a video tape from the production company or transfer house, the following items should be specified (a few of these options will be explained in the following chapters):

- Tape format (Beta or VHS)
- Audio format (hi-fi or linear)
- Placement of SMPTE time code (time code on channel one and soundtrack on channel two, etc.)
- Format of the SMPTE code (drop frame vs. non-drop)
- Vis Code
- LTC and optional VITC, and be sure both match
- Start time for the time code

By making everything clear and unambiguous to the transfer house (it doesn't hurt to put it in writing), there is less chance for error. Have the transfer house put everything they do in writing on the cassette box label, including the scan lines used for the VITC code (if used). Better safe than sorry.

"Music is essential for parades."

Cyd Charisse
Silk Stockings

THE BASICS OF VIDEO SYNCHRONIZATION

The basic goal of recording music to video, be it for TV or a film that has been transferred for post-production, is to create a 2 or 3-channel recording that can be transferred back to video or mag and synchronized to the picture. The problem that must be overcome is that the motors for the various tape machines used in a music recording (a multitrack and a mastering deck) do not run at perfect speed all the time. If the speed of a tape machine is unpredictable, how can perfect timings be maintained? The answer is, of course, by using time code.

The edited master video tape can be considered as the reference to which all other machines must be synchronized. Ultimately, it is the video image with which the music must align. Whether or not multitrack tape is used in the record-

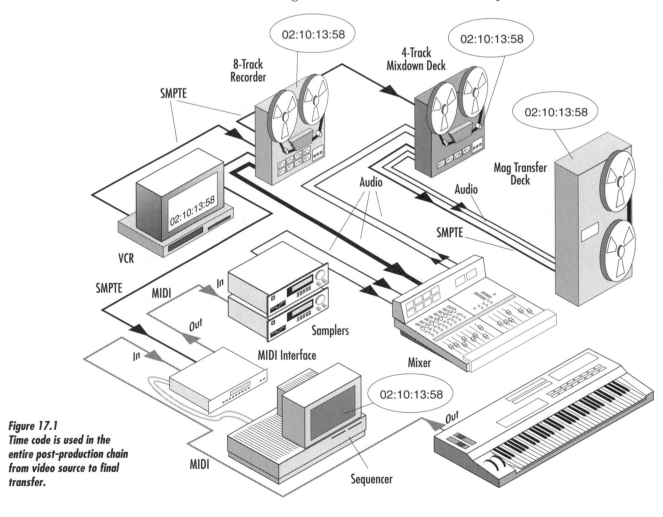

Figure 17.1
Time code is used in the entire post-production chain from video source to final transfer.

ing of the music, it is the final music mix that will be transferred back to mag or video tape for the final dub. The system that transfers the music, typically from 1/2" 4-track audio tape, will synchronize the motors of the tape machine playing the music with the mag or video recorder, ensuring that every SMPTE time on one tape is synchronized with the same point on the other tape.

This means that the music recorded onto the tape must be in exact alignment with the SMPTE code on the music master tape, each hit aligning with the time code number for which it was calculated. This should not pose a problem as long as the time code was recorded in one of these ways:

✆ The time code on the master audio tape is the same as was used by the sequencer generating the music (if no multitrack tape was used).

or

✆ The time code on the master audio tape was copied from the multitrack during the music mixdown (negating any speed fluctuations in either machine).

Although all-electronic scores for films and television have become common, multitrack tape is still used in the majority of these recordings. Care must always be given to the use and transfer of time code during the entire process of recording and mixing any score. The time code recorded onto the multitrack for sequencer or automation control may be transferred from the video tape being scored, or can be recorded fresh from a time code generator. Unless you have a multitrack and mixdown deck capable of locking together with a synchronizer, time code on the final mixdown tape should be copied from the multitrack during the mix.

If multitrack tape is not used, the time code on the final mixdown tape must either be copied from the SMPTE time code source being used to drive the sequencer (usually from an audio track of the video tape), or must drive the sequencer itself with its sync track. The correct techniques to do this will be explained later on. If these simple rules are adhered to, the chances of drift or incorrect musical timings effectively vanish. All tapes—video, multitrack, and mixdown—share the common language of time code. The time code recorded onto audio tape must match the format ("drop frame" or "non-drop") and start times of the code on the video cassette being used for the scoring.

RECORDING TIME CODE TO TAPE

Recording SMPTE time code onto video tape must be done by a special video facility with the ability to synchronize the code with the frames of the video tape itself. However, in the composer's studio, there may be a need to record SMPTE time code onto a multitrack tape that will be used in conjunction with the video and a MIDI sequencer. Recording time code onto multitrack tape is accomplished in the same way as described earlier in the book. However, there are a few elements that are unique to working with multitrack and video together.

THE FINAL GOAL

The end result of a composer's work is a stereo master recording that is given to the production company to be added to the picture. Naturally, the music must synchronize exactly with the picture as planned. Therefore, any variations in the tape speed of the audio or video recorders used in the process must be equalized in order to assure perfect synchronization between picture and sound.

As described earlier, the master tape returned by the composer to the production company is re-transferred for a final mixdown with dialogue and sound effects. In the case of film, the music is transferred to mag. For video, it is typically transferred onto 3/4" or 1" video tape. A SMPTE code included on the mixdown (see Chapter 21 on *Mixdowns*) must match the SMPTE from the original video tape. The device that transfers the music, called a *resolver*, matches the SMPTE code from the original tape with the SMPTE on the music tape. If all the tempo calculations have been made properly, the two tapes will synchronize perfectly, even if any of the tape machines used in the recording work were not running at exactly the right speed.

There are two ways to generate the code that will go onto the sync track of the multitrack music tape:

1. Copy the video tape's SMPTE track onto the multitrack and from there to the final master tape during mixdown using a time code reshaper or regenerator.

2. Record new code onto the multitrack in the same SMPTE format and with the same start time as the video tape with any reliable SMPTE generator. The time code can be used for synchronization with the video, the sequencer and the final mixdown tape.

In either case, you will put time code on the sync track of the multitrack tape that matches the time required by the cue. In the final transfer to mag or video tape, the time code on the multitrack tape will match up with the original scene's time code.

PREROLL AND POSTROLL OF TIME CODE

Some preparation must be undertaken when using multitrack tape recorders in film or video music production. The first step is to properly record a SMPTE time code stripe onto one of the tracks of the tape. This was described earlier in Chapter 6 on *Multitrack Recording*.

As mentioned earlier, there are a few differences between multitrack recording for picture and multitrack recording strictly for music.

- The time code numbers on the multitrack should match the time code numbers from the video tape exactly. This is accomplished by transferring the code directly from the video tape to the multitrack by means of a SMPTE code *regenerator* (described in the next section).

- Because of the operational requirements of the equipment used to transfer music from audio tape to video tape or 35mm mag, there should be a minimum of 20 seconds of code before and after the music. Failure to put adequate *preroll* (time code prior to the start of the music) and *postroll* (time code past the end of the music) can make transfers impossible. This is very bad indeed.

For example, if a cue begins at 02:04:05:10 and lasts for 35 seconds, you will want to record a sync track onto the multitrack that begins at approximately 02:03:45:10 and goes until 02:05:00:00. This leaves plenty of time before the cue for all the transfer equipment to lock the music with the video tape or film to which it will be transferred. It also leaves some space at the end to allow for a sustained note or chord that lasts longer than the scene for fade-out by the engineers in the final mix. If a composer sends a tape to a transfer house, they

should always be consulted about the appropriate amount of preroll desired by the equipment used at the facility.

REGENERATION AND RESHAPING TIME CODE

SMPTE time code packs a lot of information into a very small amount of tape. In the common 29.97 FPS mode for standard video, a SMPTE time code generator must send about 2400 digital bits every second onto the tape. Considering the relatively slow speed of video tape and the fact that, for every SMPTE bit there are two events (rising edge and falling edge of a square wave on the tape), this packs a slew of information onto every inch of tape. Any significant error in reading those bits from tape could cause a SMPTE reader or sequencer to do bad things, such as losing sync or jumping to a different time.

There are a number of situations in which the time code on one piece of tape (audio or video) must be transferred to another tape. One example of this is while mixing music or copying tapes which have SMPTE time code. While the audio tracks can be copied with little noticeable degradation in sound quality, there may be enough signal loss to make the time code unreliable.

For this reason, many SMPTE generators and readers have additional capabilities to prevent such problems when copying time code from one tape to another. One function is called *reshaping,* or *restoring* time code. Another is called *regenerating* time code.

In reshaping time code, a sync device reads time code from a tape and uses special filter circuitry to clean up the signal, getting rid of any noise or distortion it encounters. This helps to eliminate the problems that can occur in tape-to-tape transfer of time code. If the incoming code is seriously damaged and unreadable, reshaping will not fix it to the point of being readable again, but it does allow a few generations of reliable copies to be made.

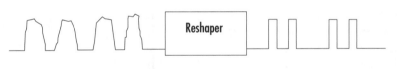

Regenerating time code is considerably more sophisticated. Instead of simply cleaning up the incoming code and sending it out again, a SMPTE regenerator reads time code and outputs fresh time code from its own built-in generator. The input and output are exactly synchronized, but the resulting code is not just a copy of the input, it is new code. This helps guarantee the quality of the code going onto the destination tape's sync track.

Reshaping code while copying works fine for a number of generations, and the equipment needed to do it is considerably less expensive than time code regenerators. Done correctly, reshaping works for virtually any transfer situation requiring the copying of time code tracks. However, code regenerators insure that the new sync track will have time code of the best possible quality, though you need to be vigilant on a few points. Regenerators can, while duplicating the incoming code, change it. The format, as well as the actual time of the new code, can be redefined by some regenerators. Regenerators can also repair damages that occur occasionally in a sync track, thus becoming indispensable in some emergency situations. The decision to use a reshaper or a regenerator can be one of economics, simplicity, availability or need. Ultimately, either can provide satisfactory results if used correctly. Rarely is there a need to use a reshaper or regenerator when feeding time code into into device such as a synchronizer or SMPTE-to-MIDI converter. Their use is strictly for tape-to-tape transfers of code, unless there is a problem with the code.

JAM SYNC
(AND JELLY TIGHT)

Audio tape is heir to many of the same slings and arrows that we mere mortals face. Anyone who has worked with multitrack tape has probably experienced the heartbreak of small dropouts (momentary loss of audio—not short people without college diplomas) at least once in their lives. While this can be problematic for the music on the tape, it is completely disastrous for time code.

As you have seen, there are a number of situations in which time code must be transferred from one tape machine (audio or video) to another. In doing so, care must be taken to ensure that the copy is as readable as the original code. Furthermore, there should be a way to correct problems such as dropouts on the source tape so that they never make it to the copy. The ability to regenerate as opposed to reshape time code while transferring has already been discussed. Many time code regenerators offer a function called *jam sync* which guarantees good quality code copies, even if the source sync track is damaged.

Brief interruptions in the time code received by a synchronizer can cause a tape machine or sequencer to stop, change speed, or possibly race forward or backward in its attempt to find the erroneous location at which it believes it should be. Occasionally, errors do occur in the master devices time code track. It is the job of the time code regenerator to fix the problem so the system can continue to function normally and in sync. When a tape machine or sync box that is slaved to the master device receives faulty code, unpredictable results can occur. A device may decide to simply shut down until it receives code that it finds intelligible. It may also decide that it is at the wrong point in its program and begin shuttling tape or relocating to another point in its sequence to compensate. In any case, it could spell bad news for everyone involved.

Jam sync, a mode of operation found in many high quality code regenerators, is one of the primary means used to avoid such catastrophes. If a regenerator in its jam sync mode reads a code that seems garbled, or appears to have jumped illogically to another location on the tape, the device will continue to generate code from its own internal source until it can, once again, make sense of the incoming code. This eliminates the effects of drop-outs and creates a fresh time code stripe that is in perfect working order.

A regenerator in jam sync mode sends out time code at all times, even when it is receiving nothing (that is one of its jobs, after all). It starts sending time code when it is first turned on by sending 00:00:00:00, and continues counting upwards with whatever SMPTE format it is set to generate. When it receives time code, it *rejams*, deciding after a few frames that the new code is a valid new time (a new tape location) and then begins sending out code starting at that location. Whenever the regenerator stops receiving code, such as when there is a drop-out on the master time code track, the device *flywheels*, meaning that it sends the next logical frame number, and continues to do so until it starts receiving code again.

If the next incoming code matches what the regenerator is sending, it will make sure that the frame boundaries haven't slipped (due to tape machine drift) and continue sending code. The code output will be completely unaffected. If the code received after the drop-out is at a new location, the regenerator will "rejam" to the new location, just as it did when it first started getting code.

Some caution must be exercised in using a regenerator with jam sync capabilities. Various brands and models of time code machines function differently. Some operate as described above, while others discontinue looking at the incoming code once they have received an initial time value. This is called *spot syncing*. The code these devices continue to generate comes from their internal clocks and do not reflect any fluctuations in tape speed in the tape machine that's sending the code. Many of the sync devices that perform jam sync in this way can also be used to synchronize the motors of tape machines and VCRs. Therefore, both the source *and* destination machines should be slaved to the synchronizer, if possible, while doing a jam sync transfer. Time code regenerators that perform jam sync as described earlier do not need to function as a master controller to the tape machine's motors.

Using Jam Sync

The use of a regenerator with jam sync is quite simple. The only thing to remember is the startup order of the devices:

☿ With the regenerator running and in jam sync mode, start the machine that will be sending the time code.

☿ Once the regenerator has performed a rejam, start the machine that will record the fresh time code.

Voilà! That's all there is to it. And speaking of fresh code, this is a good time to remind you of just how important it is to read the manuals of all the time code and sync devices you own or use. Every machine operates in a slightly different manner, and yours may require some special handling in order to get the results you need.

Time Offsets

Larger Time
- Smaller Time

Offset

If time code is being copied through a SMPTE regenerator, it is possible to change the time code numbers without affecting other aspects of synchronization. For example, a song or cue may have a count-in starting at 01:00:00:00 and the music starting at 01:00:03:12. In dubbing the music, you may wish to change the start time either to be at exactly 01:00:00:00 or to correspond to a specific time on the video. Many time code regenerators have the capability of specifying an "offset," which shifts the time code output forward or backward by a specified amount relative to the input. An offset is entered into the regenerator, which then adds or subtracts that amount from the time values it receives. The resulting code, while having new time values, still adheres to any timing fluctuations that are in the master and thus maintains perfect sync.

Matching SMPTE Hour With Reel Number

Feature length films are broken down into 2000' "reels" (sometimes called "assembly reels") lasting between 15 and 20 minutes each. These reels are projected one after the other in the movie theater. During production, these films are separated into smaller 1000' ten minute *production reels* while performing the post-production tasks of editing, sound and music.

Each production reel is given a unique number with which to identify it. All additional reels associated with the picture reel, including the dialogue reel, sound effects reels, and music reel, are given the same number for the sake of organization. Traditionally, the SMPTE time code recorded onto the reels of video, mag or other tapes has the hour value set to the reel number. For example, a cue that starts 15 seconds into the third production reel of a film would start at SMPTE time 03:00:15:00. If that same cue were found on reel seven, the start time of the cue would be 07:00:15:00. Often, when a sequencer or click machine that is locked to SMPTE does not start, it's because the start time on the SMPTE equipment is set with the wrong hour. Also, be sure to set the hour to match the reel number when striping a sync track onto a multitrack.

If the time code from the video tape is regenerated onto the multitrack's sync track, there is little chance that the time value of the SMPTE code will be incorrect.

Burn-In Desire (Window Code)

Often, a composer working from video to score a film or video will not use SMPTE-reading equipment. He or she may be using video to compose a purely orchestral or instrumental score and not be working with a MIDI sequencer or SMPTE reader. A SMPTE time code stripe on the video tape will be of no use in this situation and yet the need for exact timings is still critical. What should one do?

Figure 18.1
A video frame with "vis" code.

When a film is transferred to video tape, or a video tape is copied for post-production purposes, a "visual time code" can be electronically imprinted somewhere in each frame to indicate the current SMPTE frame number. The visual code numbers, also called a *burn-in*, *window*, or *vis code*, are created with a special device that blends an incoming video signal with time code information and outputs the composite image to another video recorder. Figure 18.1 has vis code for both the SMPTE time (hr:mn:sc:fr) as well as 35mm feet and frames.

Vis code is also important for calculating tempo. A composer using a VCR with a pause control can freeze the tape on an important frame, note the frame

number and move on to the next important event. He or she can then put together a cue sheet for calculating the click track.

For a composer or musician using SMPTE time code in his or her work, having vis code can also be useful as a confirmation of tape location, a warning for an upcoming visual event and for checking the accuracy of the music being synchronized. When requesting a video tape for post-production, be sure to request vis code in the format of the audio time code you are using (drop or non-drop). You can also request that the code be at the top or bottom of the screen as well as being displayed in SMPTE time, feet and frames, or both.

VIS CODE COMPLICATIONS

Occasionally a situation will arise when working with both visual and audio time code on 3/4" video decks in which a discrepancy of several frames between two decks will be noticed. This happens because certain manufacturers place the audio record heads of their 3/4" VCRs in different positions relative to the video record heads. A video tape recorded with one model and played with another will make evident the apparent flaw. This can be handled by determining an offset for the SMPTE reader being used or by asking the transfer house which VCR was used and using the same one.

"My sole inspiration is a telephone call from a producer."

Cole Porter

MACHINE LOCKUP

Depending on the sophistication of the sync devices and recording equipment available to a composer for recording music, it may or may not be possible to lock together a multitrack tape machine with a video recorder. Once time code has been put onto the multitrack, the video tape is no longer essential while sequencing, recording, or mixing, although watching the picture while recording can be a tremendous asset in composing, and recording.

If a synchronizer capable of locking together a multitrack and a VCR is available, there is no problem in setting up just such a system. In this setup, the VCR usually acts as the master and the multitrack is the slave. Operating the controls on the VCR causes the synchronizer to drive the multitrack and any sequencers or drum machines connected to the system.

If this rather pricey equipment is not available, there are practical alternatives. Sequencers can be locked to the video directly by means of a SMPTE-to-MIDI converter and composing can be done electronically to picture. The VCR now controls the sequencer which should be in its external clock mode.

The multitrack cannot be locked to the VCR without some sort of synchronizer. Therefore, a composer can work with a sequencer and multitrack tape for recording and mixing, but not while watching the video. This is a less desirable, but completely workable (and not uncommon) situation. As a reference, the video can be run freely while playing the multitrack. Put the VCR in pause mode just a few frames before the first frame of the cue. Play the multitrack and start the VCR at the first beat of the music. This is not exact, but it lets you know if you're in the right ballpark. With a little practice, this can be surprisingly accurate, even for long cues.

The same is true of mixing. While it is preferable to mix while watching the picture, it is not critical. The time code from the multitrack can be used to drive a sequencer that plays any "live" parts not recorded onto the tape. Everything (including the time code) goes onto the appropriate channels of the stereo master recorder.

LOCKING MIDI SEQUENCERS TO VIDEO

Just as a sequencer can be locked to a multitrack tape machine, it can also be slaved to a video recorder by using a SMPTE-to-MIDI converter. Tempos are calculated and programmed into the sync box along with the SMPTE start time of the cue, and the sequencer is placed into its external sync mode. The VCR's controls can now drive the sequencer. Sequencer tracks can be recorded and played back while watching the picture.

MIDI Song Position Pointer commands are sent out every time SMPTE code

is received by the sync box. The sequencer will automatically locate to the exact point in the music that corresponds to the proper point in the scene. If the sequencer does not start, be sure that the start time programmed into the sync box matches the start time of the cue on the video, including the hour.

Fully electronic scores can be realized in this way with a modest amount of non-musical equipment. Tape is still needed for the final mix (see Chapter 21). But a tapeless MIDI recording studio can easily be locked to picture for maximum creative control. It is not unheard of (although this is not an endorsement of this technique) for a composer to lock a tape machine or sequencer to the VCR and simply improvise an entire score while watching the picture.

MIDI Machine Control

The ability to slave a sequencer to tape opens up a number of musical possibilities. But what if you could control an audio tape machine or video deck from your MIDI sequencer? You would have a much more musical system. Standard tape machines can be located to a given spot in a song by specifying the position in time (minutes and seconds) or by a meaningless counter ("go to 134 on the tape and play"). A sequencer thinks in musical terms, like bars and beats, or verses and choruses. MIDI Machine Control (MMC) gives control over a wide range of audio and video equipment from a sequencer or other MIDI program. It is tremendously powerful. Through MMC, a sequencer can command a tape machine to locate to a point in a song, begin playing, stay synchronized to the sequencer, and even punch in and out of "record" on any track desired at any point in the music. There are a number of MMC–compatible audio machines available.

"Any musical composition must necessarily possess its unique tempo... A piece of mine can survive almost anything but wrong or uncertain tempo."
Igor Stravinsky
Conversations (1958)

USE OF SMPTE IN AUDIO POST-PRODUCTION (SFX)

Dialogue and music alone do not a soundtrack make. Sound effects, sometimes called *SFX*, are a critical part of any film. More often than not, the sound recorded while a picture is being shot does not make it to the final mix. Each sound that you hear during a film is laboriously created and edited into the soundtrack. Every door slam, gunshot, footstep, warp-drive engine, telephone ring, zipper pull, glass shatter, car tire squeal, and inevitable explosion is the result of the SFX editor's work.

Enormous libraries of sound effects exist on tapes, 35mm mag stock, and CDs. In days gone by, the only way to put a sound effect into a film was to copy the sound from its master source to mag and cut it into the film reel by hand. For video, the SFX editor had to transfer the sound onto a video tape and synchronize the VCR via SMPTE with the master video tape machine while transferring the sound to it.

Technology has helped immensely in the organization and synchronizing of sound effects. Most sound effects can be synchronized by the use of custom SFX hardware and software systems. This is done by assigning SFX events to specific frame numbers and using SMPTE time code to lock a sound effects device to the picture. The sounds are recorded onto mag, tape, or video as appropriate and then mixed into the final soundtrack along with the music and dialogue.

Technology now makes it possible to do some sound effects production in small MIDI and SMPTE-based studios. While such studios do not replace specialized sound effects facilities, much can be done with certain pieces of equipment. This is particularly important on low-budget productions in which the composer is called upon to create special sounds or sound effects that are not referenced to the tempo of the music, but to specific actions on the screen.

SMPTE time code is the backbone of electronically generated SFX. Here are descriptions of some of the ways that SFX can be done within modest means.

I WANT MY MTC

Music is not the only application for MIDI sequencers, synthesizers and samplers connected together via MIDI. These useful devices can also be used to create and record sound effects for a picture as well. In the chapters on MIDI, you learned about System Real Time messages, which are used to convey tempo information from one device to another in a MIDI music system. There is a distinct difference between these tempo-oriented messages (Clock, Start, Stop, Continue, etc.) and SMPTE time code, which is an absolute time reference with no regard to tempo per se. Devices such as SMPTE-to-MIDI converters, which convert absolute SMPTE times into tempos, starts and stops as a reference for a sequencing system.

A relative newcomer to MIDI, *MIDI Time Code* (MTC), is nothing more than normal SMPTE time code messages sent over MIDI, using standard MIDI protocol. It is used by MIDI-based devices for synchronizing events in absolute time as opposed to indicating tempos and start times. MTC has no tempo information, just as there is no tempo information in SMPTE itself. Instead of sending Clock, Start, Stop, or Song Position Pointer messages, MTC simply sends the current SMPTE frame number.

MTC is created with SMPTE-to-MTC converters.

Most computers cannot receive SMPTE time code directly, but do have access to inexpensive (or even built-in) interfaces for sending and receiving MIDI. MTC devices, as shown here, convert SMPTE code into MIDI Time Code, which can be received by an appropriately equipped computer. Most people working with computers *and* music probably already have a MIDI interface on their computer.

Once the SMPTE has been converted into MTC and sent to the computer, special software that can recognize and use MTC is needed. Such software (or hardware) can usually do one of a number of things:

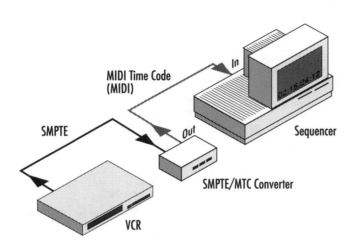

Figure 20.1

MTC converters send SMPTE data over MIDI cables.

- MTC-compatible sequencers can lock directly to SMPTE without the need for a SMPTE-to-MIDI converter.
- Tempo maps can be programmed in the sequencer instead of an external sync box.
- Sound effects stored in samplers or synthesizers can be triggered by the computer directly via MIDI.

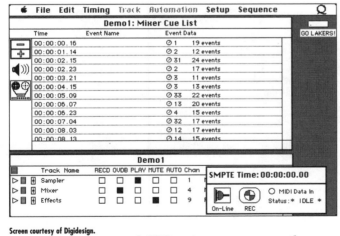

Screen courtesy of Digidesign.

Figure 20.2

Special computer software turns any MIDI sampler into a sound effects system.

MIDI events can be programmed to occur on specific SMPTE times of the picture by simply specifying the desired frame numbers. By using a VITC reader (see Chapter 15), the tape can be paused on a frame requiring a sound and the frame number can be captured into the list.

Sounds from synthesizers or samplers can be triggered via MIDI from a program or a hardware device designed to read MTC and trigger MIDI events on specific frame numbers. SMPTE is sent from the video tape to the MTC converter which then sends it to the MIDI In of the computer or sequencer in the form of MTC. MIDI note messages are then sent to the synthesizer or sampler at the preprogrammed times.

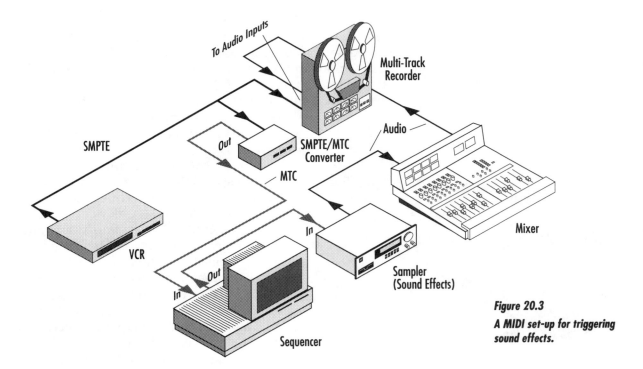

Figure 20.3
A MIDI set-up for triggering sound effects.

In the system shown above, sound effects are generated and recorded onto a tape machine while synchronized to the time code on the video tape. Later, those sound effects can be transferred using the transferred time code track on the multitrack to sync back up to the picture. With this system, an all-electronic score could be recorded and mixed simultaneously with the sound effects either blended with the music or on a separate track of the master tape. Few, if any, of the musical parts would need to be recorded to the multitrack tape.

Once the frame numbers for the sound effects are catalogued and the sounds are created, there is no reason not to put the sound effects onto the multitrack tape at the same time that you transfer the time code from the video.

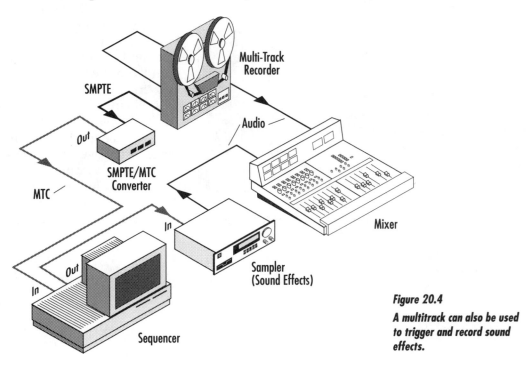

Figure 20.4
A multitrack can also be used to trigger and record sound effects.

The first step is to create the sound effects and use a MIDI sequencer or MTC-based SFX triggering program while watching the video tape. The MIDI-triggered SFX are then recorded onto the multitrack along with the time code from the video or any SMPTE generator. If the multitrack and the video cannot be synchronized, the multitrack becomes the master of the system. Once the SFX are recorded on the multitrack, they can be mixed along with the music tracks (electronic or acoustic) on the tape to the final master recording.

MTC has provisions for sending the lists of events stored in one device to another. Thus, a computer with MTC software can be used to generate and store an event list. It can then send the list via MIDI to an MTC event trigger device that sends the actual MIDI messages to the synthesizers, freeing up the computer to perform sequencer or other functions.

SFX For Cheap

As mentioned previously, there are a number of hardware and software systems for synchronizing sound effects with video by way of MTC. If you do not have an MTC-compatible system available and are called upon to do some light SFX duty, do not fear: You can accept the job with just a sequencer and any SMPTE-to-MIDI converter.

The simplest technique is simply to lock a sequencer to SMPTE time code from the video tape and trigger the SFX from a keyboard or other MIDI instrument while watching the picture. This can be added to the same sequence as the music or can be a separate sequence with an arbitrary tempo.

Sound effects are done one at a time. They should probably be recorded onto a multitrack recorder (along with the music) with an appropriate SMPTE track. Here is one possible procedure:

- ☿ Create a sequence that consists of a single note on the first beat of the song (step entry or quantization can be used to ensure that the note is exactly at the beginning). The note will trigger a synthesizer or sampler with the desired sound.

- ☿ Set the sequencer to its MIDI sync mode.

- ☿ Set the start time (offset) of the SMPTE-to-MIDI converter for the frame number where the desired sound effect should go.

- ☿ Rewind the tape to a few seconds before the sound effect's position and enable record on the track for the SFX.

- ☿ When the tape reaches the moment for the sound effect to occur, it will trigger the SMPTE-to-MIDI converter which will start the sequencer, which will, in turn, trigger the sound in the synthesizer or sampler.

MIXDOWN

Before music can be added to a picture, it must be mixed onto a tape format that is acceptable by the post production facility. There are a number of audio tape formats being used for film and video. It is of the utmost importance that the composer and production facility agree on the format to be used. This includes type of tape, tape speed, reel size, tape direction (heads or tails out), types of reference tones to be included, number of tracks, division of musical parts onto specific tracks, sync track, type of sync to use (drop, non-drop, 60 cycle), duration of sync track preroll and postroll, and SMPTE start times. This is the time when incorrect assumptions can lead to disaster and unemployment.

Here's a brief look at the mixdown formats in main use:

3-Channel Mixdown

One of the most common formats used for music mixdowns in film and video production is 2-track stereo with a third channel for time code. The music and time code are recorded onto a four-channel tape recorder with tracks 1 and 2 used for the music and track 4 for the time code. Track 3 is usually skipped as a guard against any crosstalk between the music and time code tracks.

Four-track reel to reel tape machines are widely available in either 1/2" or 1/4" formats, though 1/2" is more common and is the professional standard.

4-Channel Mixdown

Four-track mixdowns are done in much the same way as three-track mixdowns. Lead instruments, soloists and other "up-front" parts are recorded onto track 3 to allow more flexibility during the final sound mix, or "dub." The level of the time code is more critical in this case since it must not be allowed to bleed over to the solo track.

Center Channel

Another format for two-track stereo mixes is called *center channel*. It requires a special, though widely available, format for 1/4" tape.

The center channel format allows time code to be recorded onto the tape along with the music while remaining compatible with standard stereo tape machines. The time code goes onto a special center channel that is ignored by any

Left

Center Channel Time Code

Right

standard two-track machine, but can be read back by any center channel format deck. The industry standard for center channel two-track is the Nagra line of tape recorders.

2-TRACK STEREO

Most music production is mixed to 1/2" 4-track tape machines. If the only machine available to you is a standard 1/4" stereo tape deck, you can still get the job done by putting the music on one channel and the time code on the other. Always speak with someone from the transfer house or production company to make sure they can handle this format. The results will be in monaural, of course, but so are most TVs, 16mm films, and even a number of movie theaters. Low budget films often mix the music in mono.

If you can do it in stereo, that is always better (you may even get a sound-track album deal). But since one track is always reserved for time code, a standard stereo tape machine cannot be used for stereo music.

DIGITAL MIXDOWNS

There are a number of digital audio tape machines available in a variety of formats from 2-track to 48-track. Most professional machines are used exactly as their analog audio counterparts, but with startling clarity and lack of tape noise. Most digital audio recorders have extra tracks specifically for time code, thus freeing all available tracks for music or sound effects. Most, though not all, digital recorders can be slaved to a synchronizer in the same manner as an analog recorder.

Often, several tracks are reserved on the digital multitrack for the final mixdown, something not recommended on analog machines. If enough tracks are available, some film scores are mixed onto as many as nine or twelve tracks in order to separate out the various elements of the score, such as percussion, orchestra, vocals, soloists or drums. Smaller format digital machines, such as small 8-track digital recorders, can be used as excellent mixdown decks for projects needing several tracks.

For projects requiring only two channels of audio along with SMPTE time code, as is sometimes the case with television or smaller film projects, a time code DAT tape machine is a great choice. However, because DAT machines run with such accuracy of speed, the inclusion of time code is not always necessary (!!). By programming a drum machine click to occur at a specific time interval before the music begins, say two seconds, some transfer houses can work entirely without time code, but this must be discussed and confirmed before doing the mix.

Another option is to use one of the VCR's audio channels as a third audio track. In the hi-fi mode, the sound quality of most VCRs is more than acceptable. This has no effect on the digital audio recorded on the video portion of the video tape. Be sure that the time code recorded while using the hi-fi mode can be deciphered by a SMPTE reader, as there is an occasional problem with this. DAT recorders with time code tracks also are available for stereo mixes.

Time Code Regeneration

All standard audio and video tape recorders drift slightly in speed. This is one of the major reasons that sync codes were invented in the first place. As the speed of a tape fluctuates, so does the speed of the time code recorded on the tape.

As discussed earlier, when transferring music from one tape machine to another, especially in a music mixdown from multitrack to stereo for transfer to mag or video, it is vital to transfer the time code as well. It is a serious mistake to mix or transfer music from multitrack tape to the master without also transferring the time code at the same time. Unless you have the equipment to synchronize the multitrack and mixdown recorders together, it is also a mistake to generate fresh code onto the mixdown tape from a time code generator instead of reshaping or regenerating the time code from the master multitrack tape. However, it is possible to place new code onto the mixdown tape from a generator (be sure it's the same format and start time as on the multitrack and video) and lock the two machines together to ensure proper sync. Any speed fluctuations in the master must be passed along with the time code in order to cancel their effect during the final transfer to video tape or mag film. You may decide whether the time code from the master multitrack should be reshaped or regenerated on its way to the stereo master, depending on the equipment available.

If the master time code is in good condition and is recorded with good levels, reshaping is an adequate means of ensuring a high-quality signal on the mixdown tape. Except in cases of dire emergency (i.e., no code regenerators or reshapers are available and the mix is needed right away), never transfer time code directly from the multitrack master to mixdown tape without putting it

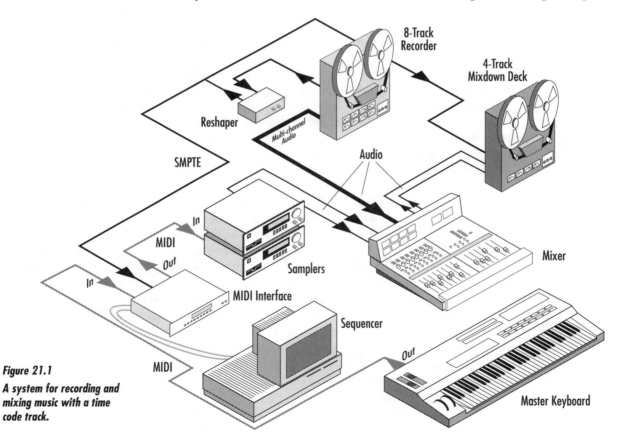

Figure 21.1

A system for recording and mixing music with a time code track.

through one of the cleanup processes above. If a sequencer is being used live during the mix along with a master tape, the time code driving the sequencer must be split and sent to both systems. The reshaper can be used to assist both systems.

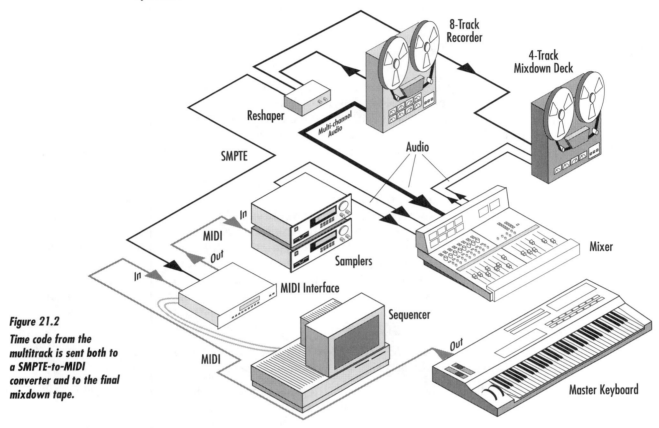

Figure 21.2
Time code from the multitrack is sent both to a SMPTE-to-MIDI converter and to the final mixdown tape.

You should now have a 2- or 3-channel mix with a time code track that the transfer house or production company can transfer to mag or video in perfect sync at all times. If you do not receive a panicky phone call from the transfer people or the music editor, you can go to bed and get a good night's sleep. You've earned it (for today).

60 CYCLE

Before SMPTE time code and MIDI time code were developed, there was a simple, inexpensive way to synchronize tape machines and monitor tape speed. Most musicians and recording engineers are all too familiar with the sonic nemesis of good recording—60 cycle hum. It comes from the AC current used to power sound equipment when it leaks into the sound system via incorrect "ground" connections that complete any electrical circuit. The 60 cycle buzz created from electrical current is extremely stable and accurate, thus making it an excellent candidate for a simple time code, much like FSK but without tempo information. It can be used to check the accuracy of tape speed by comparing the tape as it is being transferred with the AC current right from the wall or from a tuned crystal in a special sync circuit used to regulate 60 cycle sync tones, which are usually called *pilot tones*.

60 cycle sync signals have been in use for almost as long as synchronized sound in the movies. While in less use today, there are still a great many transfer houses that accept and even prefer 60 cycle sync, which is recorded in place of SMPTE time code on the master and final mixdown tapes. To bridge the gap between the two formats, there are devices available that can read SMPTE and generate the 60 cycle sync tone to record onto tape. As with any sync format, check with the transfer house to see what is acceptable and preferable for them.

MIXING TO VIDEO TAPE

Up until now, the options and standards for mixing to standard 1/4" or 1/2" audio tape for the final stereo master have been discussed. There is another option in video work that is attractive to composers wishing to see that their music stays high in quality and to budget-minded video production companies unable to afford expensive and time-consuming audio transfers. This option is to mix music directly onto the audio tracks of a video tape machine.

The sound quality is enhanced by eliminating a transfer that adds a generation to the audio portion of the final master video tape. A typical scenario goes like this: The production or post production facility brings a VCR to the composer's studio on the day of mixing. The recorder can be of any format, but usually it will be either 3/4" U-matic or high quality Beta SP "hi-fi." Check with the video people and be prepared with the correct connectors for the machine they are bringing. Female RCA connectors are typical, but some high-end machines often have XLR (3-pin cannon) connectors. All machines operate at line level.

There are a couple of ways to mix onto video tape:

 ☸ *The tape contains the final edited master of the video and a SMPTE track to send to your MIDI and synchronization equipment.*

This allows you to watch the final picture while mixing the music. This is always helpful, not only to ensure that there are no mistakes or problems with the music, but also to see the relationship between sight and sound, which may suggest certain aspects of the final mix.

SMPTE from the VCR is used to synchronize the composer's equipment by means of a SMPTE-to-MIDI converter or MTC. If a multitrack recorder is being used for the music, then it must also be slaved to the VCR's sync track.

 ☸ *The tape is a blank ("formatted") video tape that will have the picture recorded onto it after the music mixdown.*

With music recorded onto a blank tape, the production people can return to the editing room and start editing the visuals directly to the music. If they plan to add additional sound, dialogue or sound effects, they can do so by locking two or three VCRs together and running the sound from each of them to another master tape (with picture) through a mixer.

SMPTE code can be supplied by the video tape to function as the master for the composer's equipment or the composer may wish to record SMPTE onto the VCR's time code track simultaneously while recording the music. When doing this, be sure to test the results by playing the music back while sending the newly recorded SMPTE back to the sequencer by way of a SMPTE-to-MIDI converter. Put the sequencer into its external sync mode and compare the music on tape with a live playback to be sure there are no flaws in the sync track.

After discussions with the video production company, the composer may be asked to mix the music with rhythm parts on one track, and everything else on the other track. This way, the editors can make last minute changes by fading

specific elements of the music in or out. If the musical selections are short, or have not been written with specific timings, there is no need to read or record SMPTE time code.

Use the "hi-fi" mode of the video tape machine if it is available. Also be very certain that the tracking control of the VCR is set to normal. Tracking alters the speed of the video tape and can throw timings of the music or sound effects off.

LIVE MIDI SEQUENCING TO STEREO

If no multitrack tape is used for an all electronic score, music from the MIDI sequencer and synthesizers can be mixed directly to the final master tape.

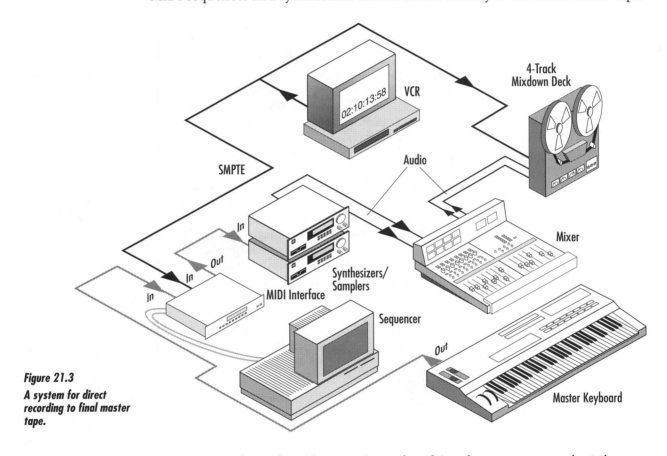

Figure 21.3
A system for direct recording to final master tape.

SMPTE from the video tape is used to drive the sequencer and, at the same time, is recorded onto the final mixdown tape. The time code from the video must be copied (and either reshaped or regenerated) to the tape simultaneously with the music as insurance against any speed fluctuations in the tape recorder.

SLATES

A *slate* is a spoken reference before the beginning of a cue on tape that identifies it. For example, on the master multitrack music tape for a film called "The Amazon," you might record the slate *the Amazon, cue 2M1, take three.* This slate would come five to ten seconds before the first warning click. Slates such as this should be mixed onto the final master right along with the music to avoid any possible confusion at later stages of transfer and editing.

In addition to the spoken slate, you should transfer the warning clicks as well, as long as they do not interfere with the first note of the music. They can be cut out later by the music editor or whoever is editing the music into the visuals. Mixing the click onto the final master also assists the editor in cases where the first note of the cue is very quiet or swells from nothing up to a noticeable sound.

Gotta Sing, Gotta Dance—Pre-recording

All of the discussions of music for film or video so far have been about post-production scoring. While scoring is often the final step of the post-production process, there is a different procedure needed for music to be performed on-screen by singers, dancers or musical groups.

Live music is rarely if ever recorded during a filming, but an on-camera performer needs a musical reference with which to perform. This is usually achieved with a special portable playback tape recorder and some speakers. By far, the most-commonly used playback recorder is from Nagra. Depending on the model (and the price tag), this reel-to-reel recorder can synchronize to time code, to a special 60 cycle pilot tone, or to a custom built-in crystal sync signal.

In recording music for on-screen use, there is no need to worry about catching hits or exact timings. The tempo, style, duration and transitions of the music are discussed and decided before the recording. Once the music is composed and approved, it is recorded as you would any normal multitrack or MIDI-based recording. The tempo used should be noted for later reference.

Unless the music for playback is extremely long in duration, there is usually no special provision for time code on the playback machine. Nagra tape decks are designed to be extremely accurate over a long period of time. The tape will be played to the performers on-stage while filming or taping. Optionally, there may be another person on the set with a second Nagra to record the sound of the dancers feet, singing or dialogue. It is possible for these machines to be connected and resolve to one another's crystal sync signal. However, this is not done often.

While recording and playing back, Nagras record a special sync tone onto their tape for an internal speed reference. Their internal crystal sync is more accurate than most standard multitrack or two-track recorders. They can record and play reasonably long pieces of music without being locked to any other time code source. Any slight inaccuracies in playback are usually handled during picture editing by shifting time slightly at each cut if there is any noticeably drift. Newer Nagras can record and resolve their motors to SMPTE time code, which effectively eliminates any potential problem. In some cases, the Nagra can be synchronized to a sync signal from the camera to achieve perfect lock-up.

If the playback is used only as a tempo reference, such as, for a nightclub or prom scene, the tape may only be played for a few measures to establish tempo, and everyone will continue dancing while the dialogue is recorded on a second recorder.

Time code used on the multitrack master should be employed normally, and regenerated onto the final mixdown used for transfer to film or video tape. Be sure to confer with the production crew for any additional requirements for the playback tape. Some people may wish to have you transfer a 60 cycle pilot tone for perfect accuracy, some may want SMPTE, and some may want nothing at all.

Continent Hopping

As you have seen, there are differences between video in Europe and the rest of the world. While most of the world has adopted the video frame rate of

29.97 (NTSC video) as standard, the European Broadcast Union (EBU) has adopted 25 FPS. This system is referred to as *PAL*.

There can be a number of problems in working on a film or video project in which some or all of the music or sound effects recording will be done in Europe. Recording and post-production facilities are all based on PAL video and EBU time code. The first step in moving a production from NTSC and SMPTE to PAL and EBU is to have the film or video converted in a way that will allow you to continue your work and, more importantly, to bring your work back to NTSC (or film) without losing sync.

PAL videos, which can either be in a VHS or 3/4" tape format, are made in one of two ways:

- The same device used to transfer film to NTSC video (the "Rank Telecine") can be used to made a PAL tape. Instead of using the 3:2 pulldown technique to convert 24 FPS film to 29.97 FPS video, the film is sped up to 25 FPS to provide a 1-to-1 match with the 25 FPS format of PAL. This results in a 4% increase in the speed of the action on the tape. While the film is being transferred, EBU time code is recorded onto a linear audio track or address track.

- A sophisticated device called a "standards converter" copies an NTSC video to PAL and maintains a 1-to-1 time ratio. EBU code is recorded onto an available audio or address track of the video tape.

Both the above transfer techniques present problems. The SMPTE-based resolvers, used in the United States to transfer audio to mag, universally run at either 30 or 29.97 frame time code, which is referenced to the 60 cycle pulse of AC electrical current. They will *not* work with EBU time code (just as European transfer facilities are not equipped to handle SMPTE time code—aren't standards wonderful?). Fortunately, there are some solutions.

By far, the preferable conversion technique is the standards converter, if one is available. The film transfer's speed change (sped up going to PAL and then slowed back down upon return to NTSC or film), while allowing accurate tempo calculations, will force the music to be slowed down by the same 4% as the picture. This system was designed with picture, dialogue and sound effects editing in mind, not music. All musical hits will still be frame accurate, but the music will be noticeably slower. While this may not effect simpler or less rhythmic cues, many cues may be aesthetically ruined. If a Telecine transfer is the only option available to you, a time code reader able to convert SMPTE to a 60 cycle pilot tone (as described earlier) is needed to resolve the EBU time code. Some time code resolvers (such as the Lynx Time Line) can be set to reference a 48 cycle pilot tone in reference to 60 cycle AC. This will guarantee that the audio master tape will run accurately at the desired speed.

In using a standards converter, there is one very important point to remember: While the equipment in Europe will require EBU code, there should be a SMPTE reference in order to transfer the music upon return. The best way to facilitate this is to have SMPTE time code from the master tape reshaped or regenerated onto a second track of the PAL tape, along with the EBU code. If two audio tracks are not available for time code (you may require the dialogue track if you are still composing), make certain that an address track-capable machine is available at your destination. Put the EBU code on the address track, SMPTE time code on one audio track and the dialogue track on the other. If the music will be mixed in Europe, you must reshape the SMPTE code onto the final mixdown, so the tape can be resolved during transfer in the U.S.

Another somewhat annoying problem is the difference in the electrical current found in various parts of the world. The U.S., Canada, and many other countries have 120 volt, 60 Hz AC power, while European countries have 240

volt, 50 Hz electricity. To complicate things a little more, Japan uses 100 volts and either 50 Hz or 60 Hz depending on which part of the country you're in. Some audio equipment uses the AC frequency to gauge the speed of its motors. When tape recorders and other mechanical devices are transported from continent to continent, their speed may change.

Test any equipment that uses AC before using it in a different part of the world than where it was purchased. The owner's manual may have information about using the equipment in other countries. If all else fails, call the manufacturer's service department.

FILM AND VIDEO "SYNC-HOLES"

THE PROBLEM: SMPTE frame numbers taken from a paused video tape with a time code reader do not match the visual code burned onto the picture. Is the transfer wrong, or is there a problem with the equipment?

THE ANSWER: In stopping or pausing a video tape, there is a possibility for the audio to be stopped by the VCR before the picture has come to a complete stop. In this case, there is bound to be a discrepancy between the vis code and the SMPTE code. While this may cause some confusion, it can be downright catastrophic if there is no visual code and this technique is used to get frame numbers. Only VITC (see Chapter 15) can be used for accurate time code reading while paused.

THE PROBLEM: A click generator is sending clicks to an orchestra and MIDI sync to a sequencer at the same time. The sequence is lagging behind the live performers because of the sequence or the sounds programmed into the synthesizers.

THE ANSWER: Run the audio output of the click generator through a digital delay unit set to a short delay time (5 to 10 milliseconds to start) and no "regeneration." This will offset the click to the musicians' headphones to compensate for the the sequencer's sluggishness. The delay time can be adjusted by hand until the sequenced part sounds together with the orchestra.

THE PROBLEM: After timing and composing music for a section of film, ten frames are cut from the middle ("tightening up" as it's called), thus rendering all your hits wrong from that point on.

THE ANSWER: This problem has a simple, though not altogether pleasant answer—you must redo your calculations and the music from the changed point onward. It may be possible to fix it by simply adding one or two beats to the music at a similar tempo.

THE PROBLEM: Even after meticulous care and double checks, you get a phone call from the editor saying the music you composed and recorded for the picture is not lining-up with the visuals.

THE ANSWER: Don't be too quick to blame yourself for such a crisis. Look back at the cues in question and recheck your timings. If everything checks out then contact the transfer house to confirm their transfer process. It is a reasonable possibility that an error was made by someone there.

If it turns out that you did indeed make the error, calculate the percentage of difference in overall length between your final recording and the correct timings. Then have your recording re-transferred using a variable speed tape machine.

FADE TO BLACK

This book has provided a look at the theory and application of synchronization in the professional and home recording studio. With the wide proliferation of high- and low-end synchronization equipment, have come a number of methods, techniques and variations for accomplishing the tasks described here.

As a working musician, you will undoubtedly come across studios, production facilities, composers, and projects that work in unique, seemingly arbitrary, mysterious, or even downright incorrect ways. In some cases, this won't make any difference; in others it will lead to aggravation and problems.

When problems do come up—and they always seem to—think the situation though carefully, taking into account the concepts and methods described in this book. Then ask questions to ascertain the nature of the problem in order to find the solution. Believe it or not, synchronization can work. In fact, it can even be relatively simple and straightforward.

Synchronization relies heavily on technology, and understanding the concepts and functions of synchronization will not replace a complete working knowledge of the equipment you use. Each piece of equipment is different. In appendix A, you will find descriptions of a few products that are available for musicians and post-production sound and music editors. Read the manuals for the products you own, use, or intend to purchase. Make sure they do what you expect or need them to do.

While the concepts of synchronization are relatively constant, the systems used to apply these concepts change almost daily. It helps to remain informed by reading the appropriate magazines and taking occasional trips to the musical instrument and audio store.

As complete as this book has attempted to be, there is always more to learn and understand about synchronization. Many synchronizing devices and systems have unique features and options, not named here, which are integral to their use. Different synchronizer manufacturers will add their own jargon or concepts to their systems in order to make a device they consider competitive, powerful and complete. Sometimes these are variations of familiar functions with new names added, or you may find advanced extensions to the basic elements of synchronization in such systems. Hopefully, the concepts and descriptions you have learned here will make understanding any new concept easier.

There are also functions of some synchronizing systems tailored to the needs of video editing—a topic that could fill a book much larger than this one.

Most importantly, never assume that the people you will work with on a project know what they are doing! Discuss in detail *and in advance* the techniques you wish to use for achieving synchronization. The composer, engineer, post-production facility, transfer house and mixing studio must all be in agreement about all phases of production to ensure that nothing goes wrong. This becomes the ultimate synchronization, from machines to machines, machines to people, and people to people.

GLOSSARY

accelerando: An increase in the tempo of a musical piece. See *ritardando*

ADR: Stands for "Automated Dialogue Replacement," the process of re-recording actors' voices in sync with the picture. See *looping*.

articulation: The duration and manner in which a note is played.

autolocator: A sophisticated remote controller for multitrack tape recorders that moves the tape to specific locations.

Beta: A format of 1/2" video cassettes for consumer use. See *VHS*.

BPM: Stands for "Beats Per Minute," and is used to indicate musical tempo.

burn-in: Visual display of SMPTE time code on a video tape or video monitor (also called "vis code").

capstan: The small metal roller that guides audio tape across the heads of a tape recorder.

chase: The ability of a slaved recorder or sequencing device to follow the location of the master device.

click egg: A special measuring tool used by music editors to mark film frames for synchronization.

click track: An audible click used as a tempo guide for musicians while recording.

common time: Musical time signature that indicates four beats in each measure.

Continue: MIDI message used to tell all clock-based devices in the system to start playing from the point at which they last stopped. See *Start, Stop*.

control track: Sync code used internally by VCRs to regulate tape speed.

count-in: Audible preparatory beats used to indicate tempo to musicians before the first note of the music.

count off: see *count-in*.

cue: Music written for a particular scene in a motion picture or video.

cue sheet: A list of significant events in a scene that may be emphasized in the music.

DAT: Stands for "Digital Audio Tape," a format for digital cassette recordings.

dB: Stands for "decibels," a unit of measurement for volume used in audio engineering.

dbx: A popular format for analog tape noise reduction.

digital metronome: A highly accurate metronome calibrated in frames per beat for use in recording film scores.

DIN Plug: The standard hardware used for all MIDI connectors.

Dolby: Techniques for noise reduction and 4-channel sound used in films; named for its inventor, Ray Dolby.

drop frame: SMPTE format that leaves out 2 frame numbers each minute to compensate for video's frame rate of 29.97 frames per second.

drum machine: Device that emulates the sounds of drums or percussion instruments and can record rhythm patterns.

dub: The final mixing of all sound elements for a film or video.

EBU: Stands for "European Broadcasters Union," the technical group that develops video standards for Europe.

EDL: Stands for "Edit Decision List," a listing of frame numbers used for editing or creating sound effects for a video tape.

field: Half of a video frame that contains all the odd or even lines of the image.

flatbed: A special table used for editing film and soundtracks together. Also known as a *Kem*.

flywheeling: Technique used by time code regenerators while incoming code is interrupted (see *jam sync*).

FPB: Stands for "Frames Per Beat," a method for expressing tempo. Used in film and video scoring.

FPS: Stands for "Frames Per Second," used for expressing frame rates.

frame: A single image on a film or video tape. Also used to refer to the amount of time the frame is shown.

frame rate: The speed at which a given visual medium records and replays images in the form of frames. Expressed in terms of frames per second.

FSK: Stands for "Frequency-Shift Keying," a popular audio synchronization technique.

groove: Musical slang that means a musical part sounds good in relation to the other parts of the music.

guard track: The empty track left between the click or time code track and the music tracks on a multi-track recording.

hi-fi: Special high-quality audio method found on some better grade VCRs.

hit: A musical event that occurs at exactly the same moment as a specific visual event on the screen.

interlaced: The blending of odd and even lines of video images in each frame onto a video monitor.

jam sync: A technique that replaces damaged time code with newly generated code during a transfer.

Kem: See *flatbed*.

lay down: Slang expression meaning to record a track onto audio tape.

lifters: The devices that pull the tape away from the tape heads during fast-forward or rewind.

linear track: The non "hi-fi" audio track on Beta or VHS video tape.

lock-up: Slang referring to multiple devices such as tape recorders that are successfully synchronized.

looping: Slang term for Automated Dialogue Replacement. See *ADR*.

LTC: Stands for "Longitudinal Time Code," refers to SMPTE time code recorded on the audio tracks of a video tape.

M.M: Stands for "Maelzel's Metronome." Used for tempo indications in beats per minute on printed musical scores.

mag (or mag stock): Sprocketed film coated with the magnetic material used on audio tape for film sound recording.

master: A device designated to control other devices (slaves) in a system.

master time code (MTC): SMPTE time code that is sent by a master device to a synchronizer.

metronome: A device used to produce an audible click for keeping a steady tempo.

MIDI: Stands for "Musical Instrument Digital Interface," the technology that allows compatible musical devices to be combined into a single system.

MIDI Clock: MIDI code sent by a sequencer or drum machine at the rate of 24 times per beat to synchronize the tempo of other clock-based MIDI devices in the system.

MIDI Time Code: MIDI messages that represent SMPTE time code.

millisecond: 1/1000th of a second.

Moviola: Popular brand of film viewer used by editors and composers.

MTC: Stands for both "MIDI Time Code" and "Master Time Code."

multitrack recording: Audio recording technique that keeps each musical part discretely on its own area of the tape.

Nagra: An industry standard reel-to-reel tape recorder used on the set for motion picture and video sound.

NDF: See *non-drop frame*.

non-drop frame: SMPTE format that numbers each frame of a video tape sequentially.

NTSC: Stands for "National Television Standards Committee," but is also used to refer to the format used by all video signals in the US.

offset: The time difference between two specified events, or the SMPTE time for beginning a cue or sequence.

optical track: Technique used by 35mm films for representing sound with a light beam passing through a special track on the film.

PAL: 25-frame-per-second video format used throughout Europe.

parts per quarter note: Also known as PPQN or PPQ. The resolution of a musical device's timebase, based on the number of clock ticks each quarter note.

PCM: Stands for "Pulse Code Modulation," a technique for digital audio recording.

PCM Recorder: A digital audio recorder.

persistence of vision: A neurological function that blends rapidly changing still images so that they appear to be moving.

pilot tone: An audio signal recorded to tape which precedes timecode.

polyphonic: The ability of an electronic musical instrument to play more than one note at a time.

postroll: Time code recorded after the end of a musical section to allow synchronization devices to continue running.

PPQ: See *Parts Per Quarter Note.*

PPQN: See *Parts Per Quarter Note.*

preroll: Time code recorded prior to the beginning of the music. Used to give tape machines and other devices the opportunity to synchronize before the music begins.

production reel: 1000' reel of film or mag used in film post production.

pulse wave: Narrowly-shaped electrical pulse used in most types of sync signals.

punch: A visual flash put onto a film or video image to indicate an important event for synchronization.

real time: A description of events at the same pace as the events themselves.

regenerator: A device that reads time code from tape and outputs new time code.

reshaper: A device that removes distortion and noise from SMPTE time code during a transfer.

resolution: The number of divisions into which a clock-based device divides a unit of time such as a quarter note.

resolved: One tape machine successfully synchronized to another that is running freely.

resolver: A device that reads speed fluctuations in a master tape recorder and compensates for them in a slave.

rhythm: The motion of events (notes) within a piece of music.

ritardando (or "ritard"): A gradual decrease in the tempo of a musical piece.

rough cut: An incompletely edited version of a film or video.

rubato: Musical term referring to music with no steady tempo.

sampler: An electronic musical instrument capable of digitally recording, manipulating and playing back any acoustic sound.

sequencer: A device or computer program that records incoming MIDI information, allows it to be edited and replays it.

SFX: Slang abbreviation for "sound effects."

slate: Verbal announcement prior to the beginning of a sound recording for identification.

slave: A device that can be operated from or responds to the actions of another device.

slave time code (STC): SMPTE time code that is sent by a slaved device to a synchronizer.

SMPTE: Stands for "Society of Motion Picture & Television Engineers," the technical group that developed SMPTE Time Code.

SMPTE reader: A device able to accept and utilize incoming SMPTE time code.

SMPTE Time Code: The industry standard synchronization signal used for motion picture and television sound. It numerically identifies each moment of time in a film or video.

SMPTE-to-MIDI converter: A device that relates SMPTE time code to tempo and sends MIDI clock messages at that tempo.

Song Position Pointer: A MIDI message that commands sequencers or drum machines to locate to a specific point in their sequence.

Song Select: A MIDI message that tells a sequencer or drum machine which song in its memory to play.

spotting: The process of selecting the sections of a film to which music will be added.

SPP: See *Song Position Pointer.*

sprockets: Small holes along the sides of film used by a camera or projector to move the film into place.

stabs: Musical slang for short sound bursts used for heavy accents.

Start: MIDI message sent by a master device to tell all other clock-based devices in the system to start playing from the beginning of their sequence.

start time: The SMPTE time to begin a musical cue.

Stop: MIDI message that tells all of the clock-based devices in the system to stop playing or recording.

streamer: A sweeping diagonal line that is placed across a film or video image to indicate a significant upcoming event for synchronization.

stripe: To record a sync signal onto audio tape.

sweetening: The recording of additional music or sound material after the initial recording sessions.

sync: Short for "synchronization."

sync pop: An audio beep heard eight seconds before the first frame of a reel; used to synchronize visual and sound reels in post-production.

sync signal: An audio signal recorded onto tape used for the synchronization of clock-based devices connected in the system. See *SMPTE* and *FSK.*

synchronizer: Any device that assists in synchronization of audio and visual devices.

synthesizer: A musical instrument that produces sound by the use of electronic circuitry.

System Real Time: MIDI messages that synchronize the performance of any clock-based MIDI devices.

tach: Electrical pulses used by a tape machine to regulate the speed of its motors.

tach pulses: See *tach.*

tempo: The rate at which musical beats occur.

tempo map: A series of tempo changes stored in a synchronization device or sequencer.

3:2 Pulldown: Technique that transfers film at 24 frames per second to video running at 29.97 frames per second.

time stamping: Technique used by MIDI sequencers to calculate the time intervals between incoming MIDI events.

timebase: Small divisions of time used to measure the durations of and between musical events. See *PPQN* and *resolution.*

timebase converter: Synchronizer capable of converting one timebase into another or into MIDI Real Time messages.

transfer: Copying audio, video or sync signals from one recorder to another.

TTL Level: Stands for "Transistor-Transistor Logic." It is the standard output voltage used by almost all clock-based devices.

U-matic: The standard format for 3/4" video cassettes and VCRs.

Ultra-Stereo: System for making 4-channel sound used in some 35mm films.

VCR: Stands for "Video Cassette Recorder," the standard video machines used in homes.

VHS: The most popular format of 1/2" video cassettes for consumer use.

vis code: Visual display of SMPTE time code on a video tape or video monitor (also called "burn-in").

VITC: Stands for "Vertical Interval Time Code," pronounced "vit-see." Refers to SMPTE time code recorded in the video signal of a video tape.

VU: Stands for "Volume Unit." One of the ways that the level meters on tape recorders and mixers are calibrated.

FOR FURTHER READING

This book has brought together the areas of audio, film, video, recording, composing, MIDI, SMPTE, the recording and movie industries. Here is a listing of materials that may further open these worlds for you:

Alkin, E.M.G. *Sound With Vision; Sound Techniques for Television And Film*, New York; Crane, Russak, 1973

Anderson, Gary H. *Electronic Post Production: The Film-To-Video Guide*, White Plains, NY; Knowledge Industry Publications, 1986

Blake, Larry. *Film Sound Today: An Anthology of Articles From Recording Engineer/Producer*, Hollywood, CA; Reveille Press, 1984

Hagen, Earl. *Scoring For Films; A Complete Text*, New York; Criterion Music Corp., 1971

Hollyn, Norman. *The Film Editing Room Handbook*, New York; Arco Publications, 1984

Lustig, Milton. *Music Editing For Motion Pictures,* New York; Hastings House, 1980

MIX Annual Recording Industry Directory, Berkeley, CA; Mix Publications Inc., Annual

Rona, Jeffrey C. *The MIDI Companion*, Milwaukee, Wisconsin; Hal Leonard Books 1994 (highly recommended!)

Skiles, Martin. *Music Scoring For TV And Motion Pictures* 1st Ed., Blue Ridge Summit, PA; Tab Books, 1976

Thomas, Tony. *Film Score: The View From The Podium*, edited and introduced by Tony Thomas, South Brunswick, NJ; A.S. Barnes, 1979

Weis, Elizabeth and John Belton (ed.) *Film Sound: Theory And Practice*, New York; Columbia University Press, 1985

SYNCHRONIZATION DEVICES

STUDIO 5 — OPCODE SYSTEMS

The Studio 5 is typical of the MIDI interfaces available for personal computers. Designed for the Apple Macintosh, this device provides 15 MIDI Ins and Outs for access to 240 channels of MIDI. Additionally, it has SMPTE In and Out and can read, write, regenerate and jam sync any time code format. An Audio In jack allows any source of click to be converted into a sequencer tempo map.

Photo courtesy of Opcode Systems

CUE — OPCODE SYSTEMS

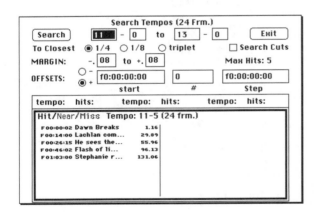

A software program for the Macintosh that assists composers writing for film and video. It compiles cue sheets, calculates timings for catching all "hits," generates click tracks, MIDI clock, displays streamers and punches and can create tempo maps that can be exported to outside sequencers and SMPTE-to-MIDI converters. The program reads standard MIDI Files and plays them back with the tempo map created within the program. When used with a SMPTE to MTC converter, it will capture and display SMPTE numbers on the computer's screen. Many of the MIDI sequencers available today integrate tempo calculations and manipulation.

ZETA THREE — ADAMS SMITH

A lower cost synchronizer that locks two tape transports together as well as generate MIDI clock and MIDI Time Code. Tempo maps can be created on the front panel and stored into memory. It has an extensive set of menus for performing virtually any SMPTE-related sync task.

Photo courtesy of Adams Smith
Photo courtesy of Adams Smith

2600 — ADAMS SMITH

Photo courtesy of Adams Smith

An upgrade from Adams Smith's Zeta system. Its modular design is able to handle systems with more than two tape machines or video decks. It is also capable of reading and converting SMPTE LTC time code, generating window code, and interfacing with a computer for more sophisticated graphic control.

Q-SHEET A/V — DIGIDESIGN

Courtesy of Digidesign

Software for the Macintosh computer specially designed for MIDI-based sound effects' synchronization and mixing automation. It reads MTC and triggers sounds by way of individual MIDI notes. It can also use MIDI controller messages or the computer's mouse to operate on-screen faders used for MIDI-based mixers.

PPS-1 AND PPS-100 — J. L. COOPER ELECTRONICS

The PPS-1 is a simple and economic non-SMPTE tape sync device which uses a proprietary "smart FSK" sync code allowing it to read the location on the tape and send MIDI Song Position Pointer Messages to the sequencer for auto-locating. This overcomes the major limitation of standard FSK. The PPS-1 also generates MTC.

The PPS-100 is considerably more advanced than the PPS-1. Additionally, it can read or write any SMPTE format, specify any SMPTE time to trigger sound effects or audio processing changes with MIDI messages (in real-time or from the front panel), send MTC, MIDI clock with Song Position Pointer and can have tempo maps programmed into its memory.

Photos courtesy of J.L. Cooper Electronics

SBX-80 — ROLANDCORP/U.S.

Photo courtesy of RolandCorp/U.S.

This was one of the very first SMPTE-to-MIDI converters released, and continues to be used regularly by a wide range of musicians. It became one of the more popular systems for home and small MIDI-based studios. It reads all SMPTE formats, but can only generate code at 30 frame non-drop. It creates tempo maps either by programming them from the front panel, tapping on a button, or from any audio click. It generates MIDI clock, Song Position Pointer, and clock output with a selectable timebase.

FILM COMPOSERS TIME PROCESSOR — Auricle
Control Systems

Photo courtesy of
Auricle Control Systems

The "Auricle" is an amazingly sophisticated scoring calculation program for the Commodore 64 and Yamaha C1 computers. It was the first such program to become available and has been lauded with a number of awards including a technical Emmy and Oscar. The program provides clicks and MIDI output to run recording sessions with or without synthesizers. The version for the C1 can lock to SMPTE time code and can superimpose streamers and punches on top of the video image.

SHADOW and SHADOW II — Cipher Digital, Inc.

Photo courtesy of Cipher Digital, Inc.

The Shadow was one of the first synchronizer/controllers to find popularity in recording studios. The Shadow II keeps any pair of synchronizer-compatible tape machines locked to within 1/100th of a frame accuracy. There is an optional remote controller, the Shadow Pad, for operating the device, and the device can interface with most any personal computer.

MIDiiZER - TASCAM

Photo courtesy of TASCAM Corp.

This device combines the features of a tape machine transport and a full functioned SMPTE-to-MIDI converter. Tempo maps can be entered in to the unit numerically, by tapping or from an external click source. The tempo maps can be edited in a number of ways and can be used to drive any MIDI or clock-based devices.

The MIDiiZER can drive most any controllable audio or video tape transport. This gives it the powerful ability to locate a tape to a specific measure number by calculating the SMPTE time from the internal tempo map. In addition to locating, the MIDiiZER can automatically punch in or out of record on newer TASCAM recorders. The device can read and write any SMPTE or EBU format and can operate between 1/20th and 100 times normal tape speed.

STREAMLINE - OFFBEAT SYSTEMS

Photo courtesy of Offbeat Systems

Streamline is a hardware and software package based on the IBM PC for scoring and recording films. The software can be used to calculate tempos for a given cue with a number of variations. The system's hardware can generate clicks, MIDI clock and song position pointer, and can superimpose streamers and punches over a video signal. The program also has a built-in word processor that music editors can use to create cue sheets for the composer.

FOSTEX SYNCHRONIZATION PRODUCTS

Fostex has become well known as a maker of lower cost 8- and 16-track recorders. Fostex has developed a number of synchronization devices to control these and other compatible recorders. They can function independently or in combination with each other as an expandable system.

The model 4050 functions as an auto-locator and remote control for Fostex multitrack recorders. It can be programmed with a tempo map from its front panel (no click input) and can locate the tape either by SMPTE time or by measure. It can be programmed to do punch ins and outs and allows these to be rehearsed without erasing anything from the tape.

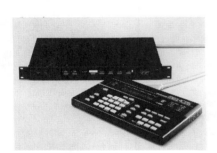

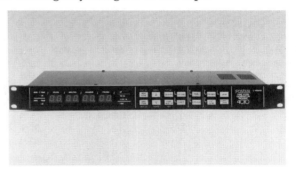

Photos courtesy of Fostex Corp.

The model 4030/4035 can synchronize up to four audio or video recorders. It can store location points and offsets between all connected recorders. These devices do not synchronize MIDI or clock-based devices and do not generate or regenerate SMPTE time code. The model 4010 is a SMPTE generator and reader. It generates and reads all formats of time code and can perform jam sync. It has a special port to connect it with the model 4030, thus allowing control over tape transports as well. The model 4011 can read or write VITC time code and can insert visual time code to a video signal.

BPM DELAY CHART

TEMPO / DELAY

bpm	fpb	♩	♪	♪³	♬	♬³
50	28 6	1200.00	600.00	400.00	300.00	200.00
51	28 2	1176.47	588.24	392.16	294.12	196.08
52	27 6	1153.85	576.92	384.62	288.46	192.31
53	27 1	1132.08	566.04	377.36	283.02	188.68
54	26 5	1111.11	555.56	370.37	277.78	185.19
55	26 1	1090.91	545.45	363.64	272.73	181.82
56	25 6	1071.43	535.71	357.14	267.86	178.57
57	25 2	1052.63	526.32	350.88	263.16	175.44
58	24 7	1034.48	517.24	344.83	258.62	172.41
59	24 3	1016.95	508.47	338.98	254.24	169.49
60	24 0	1000.00	500.00	333.33	250.00	166.67
61	23 5	983.61	491.80	327.87	245.90	163.93
62	23 2	967.74	483.87	322.58	241.94	161.29
63	22 7	952.38	476.19	317.46	238.10	158.73
64	22 4	937.50	468.75	312.50	234.38	156.25
65	22 1	923.08	461.54	307.69	230.77	153.85
66	21 7	909.09	454.55	303.03	227.27	151.52
67	21 4	895.52	447.76	298.51	223.88	149.25
68	21 1	882.35	441.18	294.12	220.59	147.06
69	20 7	869.57	434.78	289.86	217.39	144.93
70	20 5	857.14	428.57	285.71	214.29	142.86
71	20 2	845.07	422.54	281.69	211.27	140.85
72	20 0	833.33	416.67	277.78	208.33	138.89
73	19 6	821.92	410.96	273.97	205.48	136.99
74	19 4	810.81	405.41	270.27	202.70	135.14
75	19 1	800.00	400.00	266.67	200.00	133.33
76	18 8	789.47	394.74	263.16	197.37	131.58
77	18 6	779.22	389.61	259.74	194.81	129.87
78	18 4	769.23	384.62	256.41	192.31	128.21
79	18 2	759.49	379.75	253.16	189.87	126.58
80	18 0	750.00	375.00	250.00	187.50	125.00
81	17 6	740.74	370.37	246.91	185.19	123.46
82	i7 4	731.71	365.85	243.90	182.93	121.95
83	17 3	722.89	361.45	240.96	180.72	120.48
84	17 1	714.29	357.14	238.10	178.57	119.05
85	16 8	705.88	352.94	235.29	176.47	117.65
86	16 6	697.67	348.84	232.56	174.42	116.28
87	16 4	689.66	344.83	229.89	172.41	114.94
88	16 3	681.82	340.91	227.27	170.45	113.64
89	16 1	674.16	337.08	224.72	168.54	112.36
90	16 0	666.67	333.33	222.22	166.67	111.11
91	15 7	659.34	329.67	219.78	164.84	109.89
92	15 5	652.17	326.09	217.39	163.04	108.70
93	15 4	645.16	322.58	215.05	161.29	107.53
94	15 3	638.30	319.15	212.77	159.57	106.38
95	15 1	631.58	315.79	210.53	157.89	105.26
96	15 0	625.00	312.50	208.33	156.25	104.17
97	14 7	618.56	309.28	206.19	154.64	103.09
98	14 6	612.24	306.12	204.08	153.06	102.04
99	14 4	606.06	303.03	202.02	151.52	101.01
100	14 3	600.00	300.00	200.00	150.00	100.00
101	14 2	594.06	297.03	198.02	148.51	099.01
102	14 1	588.24	294.12	196.08	147.06	098.04
103	13 8	582.52	291.26	194.17	145.63	097.09

TEMPO / DELAY

bpm	fpb	♩	♪	♪³	♬	♬³
104	13 7	576.92	288.46	192.31	144.23	096.15
105	13 6	571.43	285.71	190.48	142.86	095.24
106	13 5	566.04	283.02	188.68	141.51	094.34
107	13 4	560.75	280.37	186.92	140.19	093.46
108	13 3	555.56	277.78	185.19	138.89	092.59
109	13 2	550.46	275.23	183.49	137.61	091.74
110	13 1	545.45	272.73	181.82	136.36	090.91
111	12 8	540.54	270.27	180.18	135.14	090.09
112	12 7	535.71	267.86	178.57	133.93	089.29
113	12 6	530.97	265.49	176.99	132.74	088.50
114	12 5	526.32	263.16	175.44	131.58	087.72
115	12 4	521.74	260.87	173.91	130.43	086.96
116	12 3	517.24	258.62	172.41	129.31	086.21
117	12 2	512.82	256.41	170.94	128.21	085.47
118	12 2	508.47	254.24	169.49	127.12	084.75
119	12 1	504.20	252.10	168.07	126.05	084.03
120	12 0	500.00	250.00	166.67	125.00	083.33
121	11 7	495.87	247.93	165.29	123.97	082.64
122	11 6	491.80	245.90	163.93	122.95	081.97
123	11 6	487.80	243.90	162.60	121.95	081.30
124	11 5	483.87	241.94	161.29	120.97	080.65
125	11 4	480.00	240.00	160.00	120.00	080.00
126	11 3	476.19	238.10	158.73	119.05	079.37
127	11 3	472.44	236.22	157.48	118.11	078.74
128	11 2	468.75	234.38	156.25	117.19	078.13
129	11 1	465.12	232.56	155.04	116.28	077.52
130	11 1	461.54	230.77	153.85	115.38	076.92
131	10 8	458.02	229.01	152.67	114.50	076.34
132	10 7	454.55	227.27	151.52	113.64	075.76
133	10 7	451.13	225.56	150.38	112.78	075.19
134	10 6	447.76	223.88	149.25	111.94	074.63
135	10 5	444.44	222.22	148.15	111.11	074.07
136	10 5	441.18	220.59	147.06	110.29	073.53
137	10 4	437.96	218.98	145.99	109.49	072.99
138	10 3	434.78	217.39	144.93	108.70	072.46
139	10 3	431.65	215.83	143.88	107.91	071.94
140	10 2	428.57	214.29	142.86	107.14	071.43
141	10 2	425.53	212.77	141.84	106.38	070.92
142	10 1	422.54	211.27	140.85	105.63	070.42
143	10 1	419.58	209.79	139.86	104.90	069.93
144	10 0	416.67	208.33	138.89	104.17	069.44
145	9 7	413.79	206.90	137.93	103.45	068.97
146	9 7	410.96	205.48	136.99	102.74	068.49
147	9 6	408.16	204.08	136.05	102.04	068.03
148	9 6	405.41	202.70	135.14	101.35	067.57
149	9 5	402.68	201.34	134.23	100.67	067.11
150	9 5	400.00	200.00	133.33	100.00	066.67
151	9 4	397.35	198.68	132.45	099.34	066.23
152	9 4	394.74	197.37	131.58	098.68	065.79
153	9 3	392.16	196.08	130.72	098.04	065.36
154	9 3	389.61	194.81	129.87	097.40	064.94
155	9 2	387.10	193.55	129.03	096.77	064.52
156	9 2	384.62	192.31	128.21	096.15	064.10
157	9 1	382.17	191.08	127.39	095.54	063.69

TEMPO / DELAY

bpm	fpb	♩	♪	♪³	♬	♬³
158	9 1	379.75	189.87	126.58	094.94	063.29
159	9 0	377.36	188.68	125.79	094.34	062.89
160	9 0	375.00	187.50	125.00	093.75	062.50
161	8 8	372.67	186.34	124.22	093.17	062.11
162	8 7	370.37	185.19	123.46	092.59	061.73
163	8 7	368.10	184.05	122.70	092.02	061.35
164	8 6	365.85	182.93	121.95	091.46	060.98
165	8 6	363.64	181.82	121.21	090.91	060.61
166	8 5	361.45	180.72	120.48	090.36	060.24
167	8 5	359.28	179.64	119.76	089.82	059.88
168	8 5	357.14	178.57	119.05	089.29	059.52
169	8 4	355.03	177.51	118.34	088.76	059.17
170	8 4	352.94	176.47	117.65	088.24	058.82
171	8 3	350.88	175.44	116.96	087.72	058.48
172	8 3	348.84	174.42	116.28	087.21	058.14
173	8 3	346.82	173.41	115.61	086.71	057.80
174	8 2	344.83	172.41	114.94	086.21	057.47
175	8 2	342.86	171.43	114.29	085.71	057.14
176	8 1	340.91	170.45	113.64	085.23	056.82
177	8 1	338.98	169.49	112.99	084.75	056.50
178	8 1	337.08	168.54	112.36	084.27	056.18
179	8 0	335.20	167.60	111.73	083.80	055.87
180	8 0	333.33	166.67	111.11	083.33	055.56
181	7 8	331.49	165.75	110.50	082.87	055.25
182	7 7	329.67	164.84	109.89	082.42	054.95
183	7 7	327.87	163.93	109.29	081.97	054.64
184	7 7	326.09	163.04	108.70	081.52	054.35
185	7 6	324.32	162.16	108.11	081.08	054.05
186	7 6	322.58	161.29	107.53	080.65	053.76
187	7 6	320.86	160.43	106.95	080.21	053.48
188	7 5	319.15	159.57	106.38	079.79	053.19
189	7 5	317.46	158.73	105.82	079.37	052.91
190	7 5	315.79	157.89	105.26	078.95	052.63
191	7 4	314.14	157.07	104.71	078.53	052.36
192	7 4	312.50	156.25	104.17	078.13	052.08
193	7 4	310.88	155.44	103.63	077.72	051.81
194	7 3	309.28	154.64	103.09	077.32	051.55
195	7 3	307.69	153.85	102.56	076.92	051.28
196	7 3	306.12	153.06	102.04	076.53	051.02
197	7 2	304.57	152.28	101.52	076.14	050.76
198	7 2	303.03	151.52	101.01	075.76	050.51
199	7 2	301.51	150.75	100.50	075.38	050.25
200	7 2	300.00	150.00	100.00	075.00	050.00
201	7 1	298.51	149.25	099.50	074.63	049.75
202	7 1	297.03	148.51	099.01	074.26	049.50
203	7 1	295.57	147.78	098.52	073.89	049.26
204	7 0	294.12	147.06	098.04	073.53	049.02
205	7 0	292.68	146.34	097.56	073.17	048.78
206	6 8	291.26	145.63	097.09	072.82	048.54
207	6 8	289.86	144.93	096.62	072.46	048.31
208	6 7	288.46	144.23	096.15	072.12	048.08
209	6 7	287.08	143.54	095.69	071.77	047.85
210	6 7	285.71	142.86	095.24	071.43	047.62
211	6 7	284.36	142.18	094.79	071.09	047.39

FPB DELAY CHART
based on 24 fps

TEMPO / DELAY

fpb	bpm	♩	♪	♪ (3)	♬	♬ (3)
26 0	55.38	1083.33	541.67	361.11	270.83	180.56
25 7	55.65	1078.13	539.06	359.38	269.53	179.69
25 6	55.92	1072.92	536.46	357.64	268.23	178.82
25 5	56.20	1067.71	533.85	355.90	266.93	177.95
25 4	56.47	1062.50	531.25	354.17	265.63	177.08
25 3	56.75	1057.29	528.65	352.43	264.32	176.22
25 2	57.03	1052.08	526.04	350.69	263.02	175.35
25 1	57.31	1046.88	523.44	348.96	261.72	174.48
25 0	57.60	1041.67	520.83	347.22	260.42	173.61
24 7	57.89	1036.46	518.23	345.49	259.11	172.74
24 6	58.18	1031.25	515.63	343.75	257.81	171.88
24 5	58.48	1026.04	513.02	342.01	256.51	171.01
24 4	58.78	1020.83	510.42	340.28	255.21	170.14
24 3	59.08	1015.63	507.81	338.54	253.91	169.27
24 2	59.38	1010.42	505.21	336.81	252.60	168.40
24 1	59.69	1005.21	502.60	335.07	251.30	167.53
24 0	60.00	1000.00	500.00	333.33	250.00	166.67
23 7	60.31	994.79	497.40	331.60	248.70	165.80
23 6	60.63	989.58	494.79	329.86	247.40	164.93
23 5	60.95	984.38	492.19	328.13	246.09	164.06
23 4	61.28	979.17	489.58	326.39	244.79	163.19
23 3	61.60	973.96	486.98	324.65	243.49	162.33
23 2	61.94	968.75	484.38	322.92	242.19	161.46
23 1	62.27	963.54	481.77	321.18	240.89	160.59
23 0	62.61	958.33	479.17	319.44	239.58	159.72
22 7	62.95	953.13	476.56	317.71	238.28	158.85
22 6	63.30	947.92	473.96	315.97	236.98	157.99
22 5	63.65	942.71	471.35	314.24	235.68	157.12
22 4	64.00	937.50	468.75	312.50	234.38	156.25
22 3	64.36	932.29	466.15	310.76	233.07	155.38
22 2	64.72	927.08	463.54	309.03	231.77	154.51
22 1	65.08	921.88	460.94	307.29	230.47	153.65
22 0	65.45	916.67	458.33	305.56	229.17	152.78
21 7	65.83	911.46	455.73	303.82	227.86	151.91
21 6	66.21	906.25	453.13	302.08	226.56	151.04
21 5	66.59	901.04	450.52	300.35	225.26	150.17
21 4	66.98	895.83	447.92	298.61	223.96	149.31
21 3	67.37	890.63	445.31	296.88	222.66	148.44
21 2	67.76	885.42	442.71	295.14	221.35	147.57
21 1	68.17	880.21	440.10	293.40	220.05	146.70
21 0	68.57	875.00	437.50	291.67	218.75	145.83
20 7	68.98	869.79	434.90	289.93	217.45	144.97
20 6	69.40	864.58	432.29	288.19	216.15	144.10
20 5	69.82	859.38	429.69	286.46	214.84	143.23
20 4	70.24	854.17	427.08	284.72	213.54	142.36
20 3	70.67	848.96	424.48	282.99	212.24	141.49
20 2	71.11	843.75	421.88	281.25	210.94	140.63
20 1	71.55	838.54	419.27	279.51	209.64	139.76
20 0	72.00	833.33	416.67	277.78	208.33	138.89
19 7	72.45	828.13	414.06	276.04	207.03	138.02
19 6	72.91	822.92	411.46	274.31	205.73	137.15

TEMPO / DELAY

fpb	bpm	♩	♪	♪ (3)	♬	♬ (3)
19 5	73.38	817.71	408.85	272.57	204.43	136.28
19 4	73.85	812.50	406.25	270.83	203.13	135.42
19 3	74.32	807.29	403.65	269.10	201.82	134.55
19 2	74.81	802.08	401.04	267.36	200.52	133.68
19 1	75.29	796.88	398.44	265.63	199.22	132.81
19 0	75.79	791.67	395.83	263.89	197.92	131.94
18 7	76.29	786.46	393.23	262.15	196.61	131.08
18 6	76.80	781.25	390.63	260.42	195.31	130.21
18 5	77.32	776.04	388.02	258.68	194.01	129.34
18 4	77.84	770.83	385.42	256.94	192.71	128.47
18 3	78.37	765.63	382.81	255.21	191.41	127.60
18 2	78.90	760.42	380.21	253.47	190.10	126.74
18 1	79.45	755.21	377.60	251.74	188.80	125.87
18 0	80.00	750.00	375.00	250.00	187.50	125.00
17 7	80.56	744.79	372.40	248.26	186.20	124.13
17 6	81.13	739.58	369.79	246.53	184.90	123.26
17 5	81.70	734.38	367.19	244.79	183.59	122.40
17 4	82.29	729.17	364.58	243.06	182.29	121.53
17 3	82.88	723.96	361.98	241.32	180.99	120.66
17 2	83.48	718.75	359.38	239.58	179.69	119.79
17 1	84.09	713.54	356.77	237.85	178.39	118.92
17 0	84.71	708.33	354.17	236.11	177.08	118.06
16 7	85.33	703.13	351.56	234.38	175.78	117.19
16 6	85.97	697.92	348.96	232.64	174.48	116.32
16 5	86.62	692.71	346.35	230.90	173.18	115.45
16 4	87.27	687.50	343.75	229.17	171.88	114.58
16 3	87.94	682.29	341.15	227.43	170.57	113.72
16 2	88.62	677.08	338.54	225.69	169.27	112.85
16 1	89.30	671.88	335.94	223.96	167.97	111.98
16 0	90.00	666.67	333.33	222.22	166.67	111.11
15 7	90.71	661.46	330.73	220.49	165.36	110.24
15 6	91.43	656.25	328.13	218.75	164.06	109.38
15 5	92.16	651.04	325.52	217.01	162.76	108.51
15 4	92.90	645.83	322.92	215.28	161.46	107.64
15 3	93.66	640.63	320.31	213.54	160.16	106.77
15 2	94.43	635.42	317.71	211.81	158.85	105.90
15 1	95.21	630.21	315.10	210.07	157.55	105.03
15 0	96.00	625.00	312.50	208.33	156.25	104.17
14 7	96.81	619.79	309.90	206.60	154.95	103.30
14 6	97.63	614.58	307.29	204.86	153.65	102.43
14 5	98.46	609.38	304.69	203.13	152.34	101.56
14 4	99.31	604.17	302.08	201.39	151.04	100.69
14 3	100.17	598.96	299.48	199.65	149.74	099.83
14 2	101.05	593.75	296.88	197.92	148.44	098.96
14 1	101.95	588.54	294.27	196.18	147.14	098.09
14 0	102.86	583.33	291.67	194.44	145.83	097.22
13 7	103.78	578.13	289.06	192.71	144.53	096.35
13 6	104.73	572.92	286.46	190.97	143.23	095.49
13 5	105.69	567.71	283.85	189.24	141.93	094.62
13 4	106.67	562.50	281.25	187.50	140.63	093.75
13 3	107.66	557.29	278.65	185.76	139.32	092.88

TEMPO / DELAY

fpb	bpm	♩	♪	♪ (3)	♬	♬ (3)
13 2	108.68	552.08	276.04	184.03	138.02	092.01
13 1	109.71	546.88	273.44	182.29	136.72	091.15
13 0	110.77	541.67	270.83	180.56	135.42	090.28
12 7	111.84	536.46	268.23	178.82	134.11	089.41
12 6	112.94	531.25	265.63	177.08	132.81	088.54
12 5	114.06	526.04	263.02	175.35	131.51	087.67
12 4	115.20	520.83	260.42	173.61	130.21	086.81
12 3	116.36	515.63	257.81	171.88	128.91	085.94
12 2	117.55	510.42	255.21	170.14	127.60	085.07
12 1	118.76	505.21	252.60	168.40	126.30	084.20
12 0	120.00	500.00	250.00	166.67	125.00	083.33
11 7	121.26	494.79	247.40	164.93	123.70	082.47
11 6	122.55	489.58	244.79	163.19	122.40	081.60
11 5	123.87	484.38	242.19	161.46	121.09	080.73
11 4	125.22	479.17	239.58	159.72	119.79	079.86
11 3	126.59	473.96	236.98	157.99	118.49	078.99
11 2	128.00	468.75	234.38	156.25	117.19	078.13
11 1	129.44	463.54	231.77	154.51	115.89	077.26
11 0	130.91	458.33	229.17	152.78	114.58	076.39
10 7	132.41	453.13	226.56	151.04	113.28	075.52
10 6	133.95	447.92	223.96	149.31	111.98	074.65
10 5	135.53	442.71	221.35	147.57	110.68	073.78
10 4	137.14	437.50	218.75	145.83	109.38	072.92
10 3	138.80	432.29	216.15	144.10	108.07	072.05
10 2	140.49	427.08	213.54	142.36	106.77	071.18
10 1	142.22	421.88	210.94	140.63	105.47	070.31
10 0	144.00	416.67	208.33	138.89	104.17	069.44
9 7	145.82	411.46	205.73	137.15	102.86	068.58
9 6	147.69	406.25	203.13	135.42	101.56	067.71
9 5	149.61	401.04	200.52	133.68	100.26	066.84
9 4	151.58	395.83	197.92	131.94	098.96	065.97
9 3	153.60	390.63	195.31	130.21	097.66	065.10
9 2	155.68	385.42	192.71	128.47	096.35	064.24
9 1	157.81	380.21	190.10	126.74	095.05	063.37
9 0	160.00	375.00	187.50	125.00	093.75	062.50
8 7	162.25	369.79	184.90	123.26	092.45	061.63
8 6	164.57	364.58	182.29	121.53	091.15	060.76
8 5	166.96	359.38	179.69	119.79	089.84	059.90
8 4	169.41	354.17	177.08	118.06	088.54	059.03
8 3	171.94	348.96	174.48	116.32	087.24	058.16
8 2	174.55	343.75	171.88	114.58	085.94	057.29
8 1	177.23	338.54	169.27	112.85	084.64	056.42
8 0	180.00	333.33	166.67	111.11	083.33	055.56
7 7	182.86	328.13	164.06	109.38	082.03	054.69
7 6	185.81	322.92	161.46	107.64	080.73	053.82
7 5	188.85	317.71	158.85	105.90	079.43	052.95
7 4	192.00	312.50	156.25	104.17	078.13	052.08
7 3	195.25	307.29	153.65	102.43	076.82	051.22
7 2	198.62	302.08	151.04	100.69	075.52	050.35
7 1	202.11	296.88	148.44	098.96	074.22	049.48
7 0	205.71	291.67	145.83	097.22	072.92	048.61

FORMULAS FOR SUCCESS

Here are some of the formulas, conversions and assorted mathematica used in film and video synchronization:

35mm film runs at 90 feet per minute

35mm film runs at 2/3 (.67) of a second per foot

35mm Film runs 3 feet every 2 seconds

1 frame of video tape is 33 milliseconds

1 frame of film is 41.67 milliseconds

Length of film to time: **$(2*(feet)/3)+(frames/24)=$ Seconds**

Time from beats and tempo: **Seconds$=(60/BPM)*(Beat-1)$**

Beat from tempo and time: **Beat$=((BPM*Seconds)/60)+1$**

Tempo from time and beat: **BPM$=(60/Seconds)*(Beat-1)$**

Here are the same formulas using FPB instead of BPM:

Seconds$=((60*FPB)/1440)*(Beat-1)$

Beat$=((1440*Seconds)/(FPB*60))+1$

FPB$=(1440*Seconds)/(60*(Beat-1))$

Tempo to delay:

60000 / BPM = ms per beat

41.67 * FPB = ms per beat

Convert BPM to FPB (Film):

1440/BPM = FPB

(for eighth-frame accuracy, take the remainder of the division, multiply it by 8 and round it to the nearest digit)
or

1440/FPB=BPM

Convert BPM to FPB (Video):
1800/BPM = FPB
or
1800/FPB=BPM

Film Frames Converted To Hundredths of a Second:

0	—	.00	8	—	.33	16	—	.67
1	—	.04	9	—	.38	17	—	.71
2	—	.08	10	—	.42	18	—	.75
3	—	.12	11	—	.46	19	—	.79
4	—	.17	12	—	.50	20	—	.83
5	—	.21	13	—	.54	21	—	.88
6	—	.25	14	—	.58	22	—	.92
7	—	.29	15	—	.62	23	—	.96

Video Frames Converted To Hundredths of a Second:

0	—	.00	10	—	.33	20	—	.67
1	—	.03	11	—	.37	21	—	.70
2	—	.07	12	—	.40	22	—	.73
3	—	.10	13	—	.43	23	—	.77
4	—	.13	14	—	.47	24	—	.80
5	—	.17	15	—	.50	25	—	.83
6	—	.20	16	—	.53	26	—	.87
7	—	.23	17	—	.57	27	—	.90
8	—	.27	18	—	.60	28	—	.93
9	—	.30	19	—	.63	29	—	.97

Eighths Converted to Decimal:

0	—	.000	3	—	.375	6	—	.750
1	—	.125	4	—	.500	7	—	.875
2	—	.250	5	—	.625	8	—	1.000

THANKS

As alone as I felt at times while writing this book, there were many people that gave me invaluable assistance and input during this time. I wish to thank Fred Selden for first showing me what a film score looked like, and what is involved in making one. Thanks to the indefatigable Gerry Lester of Adams Smith and to Bob Badami of Offbeat Systems for showing me synchronization from the other side. Many thanks to Philip Glass, Kurt Munkasci, David Frank, Bill Meyers, Basil Poledouris, Richard Einhorn, Scott Smalley, Brian Banks and the others who allowed me to put all this information into action, and to discover for myself just how badly things can go wrong and how much there is to learn. Thanks to Charles and Sharon Rudnick of Film And Video Service in San Francisco for taking the time to show me how they do things in the "Grey Area." Thank you to Maestro Micah Levy for his "timely" suggestions. Thanks to Bruce Albertine, Mark Curry and Avi Kipper, three great "men of the board" for sharing their studio experiences with me. Thanks to Bob Mills for explaining how they do it on MTV. Thanks to my good friend Jaynee Thorne for explaining the inside story of film and video transfer. My deep thanks to Lachlan Westfall for sage advice, graphical expertise, and the news.

A very special thanks to Rick Johnston, the inventor of "Cue," for sharing his deep understanding of and bemusement with these topics. Thanks to Sonus Corp., J.L. Cooper Electronics, Cipher Digital Inc., Opcode Systems and Terry Delsing of Tesla for access to tools and information. A very special "thank you" to Adam Smalley for unraveling many of the mysteries of music editing and the universe.

Special thanks to Scott Wilkinson for his great technical, mathematical, and grammatical assistance in editing this book. Without him, 2+2 are sometimes 5 and sentences frequently end with words they are not supposed to! Many thanks to Jon Eiche, Jack Schechinger and the entire Hal Leonard staff for their encouragement and help. My heartfelt gratitude to Judy Silk, for her support and patience. Finally thanks to Ronny Schiff, my editor and friend, for her enthusiasm and for so frequently asking the question "Is it done yet?"

And, of course, thanks Mom.

ABOUT THE COVER

The cover of this book was photographed directly from the screen of a graphics workstation, and nothing in the picture exists in the real world. Reels, tape, film, mountains, all were synthesized as 3-dimensional objects that can be moved about in an imaginary space in computer memory.

Is a graphics workstation as powerful and expressive as a musical workstation? Well, there's some good news and some bad news.

The good news is that 3-D graphics workstations have become much more powerful in a way that lets the artist use the computer as a window into a world, instead of having to worry about details like which object is in front and how do you light something that doesn't exist. As picture quality has improved, the price has been the need for more memory. The cover picture contains 7.5 megabytes (millions of bytes) of color and depth data, and it was created on a system with 16 megabytes of RAM and 900 megabytes of disk storage. And you thought your sampler was a big memory hog!

The bad news is in that second word, "expressive." Graphics workstations can remind you of the old days of oscillators and patch chords, when the emphasis was more on making a sound than on making music. As yet, there's no such thing as a graphics' MIDI, and you can't have several computers and programs working on the same picture. And how do you tell a computer to create a 3-D shiny aluminum tape reel or a strip of film?

The answer is: "Not easily." This picture was programmed in LISP, a computer language that's also been used in computer music applications. LISP has a couple of strong advantages; it expresses ideas easily without having to resort to numbers, and it can interpret commands "on the fly." Both were essential for the cover picture. For instance, the film was defined as a wiggly strip of so-many frames, then a frame was defined as having so-many perforations, etc. Since the data for the whole film strip overflowed computer memory, LISP's ability to create frames on the fly, freeing up memory as it went along, was crucial.

In short, the progress in 3-D graphics workstations has been wonderful, but it will be a while before you see groups of artists getting together for an evening of "jamming with pictures."

Colin Cantwell is a computer artist, and also has special effects credits in the movies *Star Wars*, *2001—A Space Odyssey*, and *Wargames*. He's looking forward to jamming with computer-based 3-D animation and music. The cover picture is from a 4"x5" color transparency photographed by Colin Cantwell, Crystal Chip, Inc., Newhall, California.

INDEX

Photography by Wren, Venice, California

ABOUT THE AUTHOR

Jeffrey Rona is a composer and arranger of music for film, video, theater and dance, as well as a synthesist, musician, writer, teacher and reformed MIDI software author from Los Angeles, California. He spent four years as a product developer for RolandCorp/U.S., creating computer-based sequencers. He is a founder and former president of the MIDI Manufacturers Association, an international consortium of MIDI and audio developers responsible for maintaining the MIDI specification. His book, *"The MIDI Companion"* is also available from Hal Leonard Books.